The Designer's Guide to

WEBType

Your Connection to the Best Fonts Online

Edited By
Kathleen Ziegler
Nick Greco

Dimensional Illustrators, Inc.

HBI
an imprint of HarperCollins International

First Published 2001 by:
Dimensional Illustrators, Inc.
For HBI, an imprint of
HarperCollins Publishers
10 East 53rd Street
New York, NY 10022-5299 USA

ISBN: 0-06-093373-9

Distributed to the trade and art markets in the US by:
North Light Books, an imprint of F & W Publications, Inc.
1507 Dana Avenue
Cincinnati, OH 45207
(800) 289-0963 Telephone

Distributed throughout the rest of the world by:
HarperCollins International
10 East 53rd Street
New York, NY 10022-5299 USA
212-207-7654 Fax

Address Direct Mail Sales to:
Dimensional Illustrators, Inc.
362 Second Street Pike / Suite 112
Southampton, PA 18966 USA
215-953-1415 Telephone
215-953-1697 Fax
Email: dimension@3dimillus.com
Website: http://www.3dimillus.com

Credits

Creative Director / Associate Editor
Kathleen Ziegler Dimensional Illustrators, Inc.

Executive Editor
Nick Greco Dimensional Illustrators, Inc.

Design and Typography
Deborah Davis Deborah Davis Design

Initial Book Design and Jacket Cover Design
Steve Bridges Bridges Design

Inset Art Page 6
Joshua Darden, Timothy Donaldson, Matius Gerardo Grieck, Jason Hogue
Featured Fonts **Zapfino 1, Zapfino 4, Plankton-b**

Inset Art Page 9
Adam Roe

Inset Art Page 16
Todd Dever, Denis Dulude
Featured Fonts **Zapfino 1, Zapfino 4, Plankton-b**

Inset Art Page 158
Matius Gerardo Grieck, Sibylle Hagmann, Adam Roe
Featured Fonts **Zapfino 1, Zapfino 4, Plankton-b**

Cover Art
Denis Dulude / 2Rebels ©2001
Matius Gerardo Grieck / [+ISM] ©2001

Table of Contents

Table of Contents

INTRODUCTION

The introduction, availability and diversity of digital type software coupled with the ease of purchasing typefaces online, has created an electronic resurgence in the quantity and quality of digital type foundries worldwide. Today's online typehouses render practically obsolete the printed paper catalogues. The instant access and downloading capabilities of the internet has fueled the creative evolution in typeface design. Commercial, independent foundries and designers currently display and sell thousands of typefonts on the worldwide web. **The Designer's Guide To Web Type**, untangles the web of complexity by showcasing the best design text and display fonts from 20 principle commercial, independent and designer foundries available on the internet.

This premiere guide book offers an alphabetical cross section to 70 digital typefonts from the subliminal to the sublime, contemporary to experimental, organic to ornamental, hand-drawn to neoclassic. The type foundries include: Bitstream, Cool Fonts, DsgnHaus, Emigre, Face2Face, fontBoy, Font Shop International, Fountain, GarageFonts, International Typeface Corporation, +ISM, Linotype Library, Lunch Box Studios, Nekton Design, Phil's Fonts, Psy/Ops, Shift, Swifty/Typomatic, T26 and 2Rebels.

Web Type is divided alphabetically by font name and includes descriptive text, font families and two inspiring typographic illustrations that feature each font in a design application. In addition, website addresses are provided for easy access. More than 200 font families with full character sets are listed in the alpha section beginning on page 158. The specimens showcase black type on white and drop out white type on black. **Web Type** features typographers from Australia, Austria, Canada, China, England, France, Germany, Italy, The Netherlands, Serbia, Sweden, Thailand and the United States. Our editors have visited the hottest foundries worldwide to bring you the latest typefonts designed to give you an insiders prospective to the coolest fonts online.

-Dimensional Illustrators, Inc.

How To Use This Book

Web Type is divided alphabetically by font name and includes descriptive text, font family listing and two typographic illustrations that feature each font in a design application. In addition, website addresses are provided for reference.

Reference Initial: Located in the upper left hand corner of each page, the letter helps to find the font alphabetically within each category.

Font Families: Details the specific font families included in the font. The complete family showings are listed in the Alpha Section starting on page 158.

Style: Categorizes the design of the typeface. A complete list of *Fonts by Style* are listed in the back of the book on page 282.

Alpha Page: Indicates the exact page of the alphabet showings. Listing includes the character sets and font families. Type is shown in black and white.

Font Description: Text describes the font features and characteristics as supplied by the designer or foundry.

Web Address: The essential key to finding the digital typefont for purchase online.

Application: Shows typographical designs using the font.

Font Designer: Indicates the typefont designer and country location.

Introduction

Digital Foundries

Bitstream - Commercial Foundry http://www.bitstream.com

Bitstream's world-renowned, award-winning Typeface Library includes an extensive library of high-quality fonts in PostScript Type 1 and TrueType formats for Windows, the Macintosh, Unix, and Linux. In August of 2000, Bitstream announced the New Font Collection (NFC) program. The NFC was established to expand the typeface library by providing a venue for publishing new typeface designs, and to seek out these designs from established, as well as, new independent designers. The Bitstream New Font Collection plans on releasing a collection of new typefaces every quarter.

Cool Fonts - Independent Foundry http://www.cool-fonts.com

Cool Fonts was created by Todd Dever in 1995 as an outlet for custom typefaces. His main application included broadcast graphics and animation. As Cool Fonts popularity grew, they offered a variety of uniquely designed fonts for the designers. All have one thing in common, "they're cool...not a speck of cereal."

DsgnHaus - Commercial Foundry http://www.FORdesigners.com

Since 1990, DsgnHaus has been a popular resource for name brand digital fonts, clip art, royalty-free photographs and information on type. DsgnHaus markets more than 15,000 fonts online including Berthold, Bitstream, E+F, FontFont, ITC, Linotype, Monotype, The Font Bureau and 1,200 of its own exclusive products.

Emigre, Inc. - Independent Foundry http://www.emigre.com

Emigre, Inc. is a digital type foundry, publisher and distributor of graphic design related software and printed materials based in Northern California. Founded in 1984, coinciding with the birth of the Macintosh, Emigre was among the first independent type foundries to establish itself around personal computer technology. Emigre holds exclusive license to more than 270 original typeface designs created by a roster of contemporary designers. Emigre's full line of typefaces, ornaments and illustrations is available in Type 1 PostScript and TrueType for both the Macintosh and PC.

Face2Face - Independent Foundry http://www.typeface2face

Face2Face was created in 1994 as a collaboration for turbulent typeface designers to showcase their challenging letterforms. The cutting edge Face2Face website not only features typefaces, but also shows typographic designs and applications in various media. Every year Face2Face publishes the electric Typomag F2F, which has a catalog of their latest fonts and special features. Face2Face fonts are available online at two locations: www.typeface2face.com or www.fontshop.de.

fontBoy - Independent Foundry http://www.fontboy.com

FontBoy.com was launched in the summer of 1995 to manufacture and distribute fonts designed by Bob Aufuldish and Kathy Warinner of the design office, Aufuldish & Warinner. The foundry maintains a web site at www.fontboy.com with a secure storefront--fonts are available in Mac and Windows formats. The foundry has released fonts ranging from the quirky and handmade to the geometrically precise. The current direction of their work incorporates more classical elements, simultaneously using process-oriented techniques to defy the designer's linear expectations. Aufuldish & Warinner try to stay focussed on what interests them rather than trying to chase trends. They prefer the wide-open early 20th century modernism, rather than the formulaic high modernism of the international style.

FSI FontShop International - Commercial Foundry http://www.fontfont.com

FSI, FontShop International, founded in 1990, is a renowned type foundry based in Berlin Germany, with an office in San Francisco. The FontFont Library has the world's largest collection of original, contemporary typefaces. This Library is unique because it contains a variety of outstanding type designs. The spectrum of styles include tasteful, high-quality text faces, eye-catching display fonts, amusing fun fonts and terrifying destructive fonts that reflect current moods and set typographic trends. The Library includes the work of the foremost typographers and graphic designers including Neville Brody, Erik Spiekermann, David Berlow, Max Kisman, Erik van Blokland, Just van Rossum and Tobias Frere-Jones. Currently, the FontFont Library has approximately 2,000 fonts and continues to grow steadily. Their cutting edge designs break new ground in style, quality and innovation.

Fountain - Independent Foundry http://www.fountain.com

Founded in 1995 by Peter Bruhn, Fountain - A Friendly Type Foundry, is an independent type foundry and design bureau located in Malmo, Sweden. Originally founded as a showcase for one designer, Fountain Type Foundry has evolved into a unique catalogue that includes fonts from designers worldwide. The fonts are now distributed through foundries and distributors worldwide.

Digital Foundries

Digital Foundries

GarageFonts - Independent Foundry http://www.garagefonts.com

GarageFonts was established in 1993, primarily as a vehicle to distribute some of the first typefaces created for Raygun Magazine. From the beginning, GarageFonts has been on the cutting edge of new typeface design. Since its inception, GarageFonts has matured a bit (although they are constantly fighting the notion of growing up.) What started as a small library of trend-setting designs has grown to include more than 600 innovative text and display faces from a crew of stand-out international type designers, with many exciting new releases in the works. Their goal is to provide type lovers with a varied collection of original, accessible text and display typefaces. From slightly twisted traditional styles to the experimental and outrageously alternative designs you expect from them, GarageFonts has something for everyone.

International Typeface Corporation - Commercial Foundry http://www.itcfonts.com

An international leader in typeface design and marketing for more than 30 years, International Typeface Corporation (ITC) collaborates with world-class designers to provide a library of more than 1,000 classic typefaces. ITC licenses its typeface library throughout the world to more than 130 companies in the graphic design, computer and printing technology fields. ITC has helped raise the standards of quality and focused attention on the ethical issues related to protection and licensing.

+ISM - Independent Foundry http://www.plusism.com

+ISM is Matius Gerardo Grieck and Tsuyoshi Nakazako, an interdisciplinary conceptual artists collective which was formed in Tokyo, now based in London. Originating from Installation Art the core idea is the crossfertilization of various media and collaborations in an attempt to subvert extrinsic content to its prevalent purpose. The +ISM font collection, existing only in digital format at www.plusism.com, has a navigational system divided into four sections introducing each font in detail.

1. Prototype.......(displaying font characteristics)

2. Concept.........(description and background)

3. Character X.....(set examples/families)

4. Interpretation..(image presentation of font)

Linotype Library - Commercial Foundry http://www.linotypelibrary.com

The Linotype Library is one of the largest libraries in the world. The importance of font usage and the loyalty and creativity of today's highly renowned international type designers have made the Linotype Library the mega center of both traditional and innovative, modern type design. The library's goal is to produce, market and license high quality fonts. New typefonts are continuously developed and tested. As a developer of the communication vehicle "font" for all visual media, Linotype Library sees itself as a partner for both designers and typographers.

LunchBox Studios - Independent Foundry http://www.lunchboxstudios.com

LunchBox Studios is a new media and motion graphics firm located in Los Angeles, California. Their purpose is to produce reaction based solutions for the media in which they work: Broadcast Design, Web Graphics, Print, Corporate Identity, Collateral, Packaging, combined with an internationally distributed type foundry. The independent foundry showcases a blend of uniquely developed typefonts.

Nekton Design - Independent Foundry http://www.donbarnett.com

Nekton Design, is essentially an illustration and design company created by Don Barnett. This includes type design, illustration and some animation created for both corporate clients and small businesses. The focus of Nekton Design is not one of type design or illustration but rather the search for interesting projects and people to develop them.

Phil's Fonts - Commercial Foundry http://www.philsfonts.com

Phil's Fonts is an international distributor of fonts from over 75 type foundries, large and small. That's more than 30,000 fonts from an international group of foundries, including Adobe, Agfa, Berthold, Font Bureau, FontFont, GarageFonts, ITC, LetterPerfect, Linotype, P22, Red Rooster, [T-26], Typo-ø-Tones, Union Type Supply and more. Phil's Fonts has been in the type business for more than a quarter century. First known as Phil's Photo, they started as a small, high-quality photolettering studio in Washington, D.C. During the 1970s and 1980s, Phil's Photo became a well-known and respected typehouse. When typesetting changed in the early 1990s, Phil's Photo evolved into Phil's Fonts. Phil's Fonts carries on the traditions and standards established by its founders. In June 1999, they acquired GarageFonts, a boutique type foundry with more than 600 typefaces.

Digital Foundries

Digital Foundries

Psy/Ops ® - Independent Foundry **http://www.psyops.com**

Psy/Ops is San Francisco's premier type studio, featuring a font library which is recognized for its understated experimentation, utility and precision. Psy/Ops offers typographic design and production services for corporate and private clients. Recent projects include development of core typefaces for Balthaser Online's web applications; redesign of the recreational and cartographic pictograms for the US Forest Service; and the creation of the official Dr.Seuss™ font set for Dr.Seuss™ Enterprises and Esprit de Corp.

Shift - Independent Foundry **http://www.shiftype.com**

Conceived in 1993 by Joshua Distler as a way of marketing fonts created for his personal projects, Shift went online in 1995 to begin sales and distribution. For more than 5 years, Shift has been offering a small library of award winning fonts with predominantly technological themes, rendered in clean, thoughtful, and all original drawings. In September of 1998 the Shift web site was relaunched with a new site, new fonts, new packaging, and the option to purchase and download fonts online.

Swifty/Typomatic - Independent Foundry **http://www.swifty.co.uk**

Established in 1997, Typomatic started life as Command Z, a magazine and font package conceived and produced by Ian Swift (Swifty) in 1994. Within a few years, he had several new fonts ready for sale. Subsequently, his thoughts turned to the web as an alternative to print. Although Swift's operation is a small adjunct to his regular graphic design commissions, Typomatic is expanding. New fonts are being developed together with a website redesign incorporating a wide range of T- shirts and limited edition prints. With a new, creative online site, Swifty/Typomatic has, "the funkiest fontz this side of Saturn".

[T-26] Type Foundry - Independent Foundry http://www.t26.com

In 1994, [T-26] digital type foundry was created by Carlos Segura to explore the typographical side of the design world. His goal "was to bring about change, expanding the perimeters of the industry from within." Segura maintains that concept, demographics and objective are the primary focus of his work. The idea was to produce affordable fonts that promote experimentation in typeface design, highlight upcoming and student designers and open minds. [T-26] differs from existing type foundries in its marketing, and the benefits afforded to both artists and customers. [T-26] remains a top choice for experimental, techno and modern fonts, and encompasses the work of many well known type designers including Margo Chase, Stephen Farell, Adam Roe, Rian Hughes and Chank.

2Rebels - Independent Foundry http://www.2rebels.com

2Rebels, a small business with big ideas, was formed in 1995 in Montreal, Canada. Their objective was to create fonts for other like-minded designers. 2Rebels offer a variety of typefaces ranging from the traditional to the experimental. Going beyond the classical, their approach is at times subversive, transforming the normal and accepted into innovative and personal font-images. 2Rebels' aim is to contribute to the on-going revolution in typography and invites others to do likewise.

Digital Foundries

FONT SHOWCASE

A

Air Mail

Font Name
Air Mail

Font Families
Air Mail Regular
Air Mail Postage ✉
(Symbols)

Style
Distressed
Experimental
Ornamental
Textured

Alpha Page
160

Font Designer, Adam Roe *United States*

Air Mail is an experimental font designed by Adam Roe with fun in mind. It is composed of all the details and stamps from Lunchbox Studios' mail over a one month period and is comprised of two parts: Air Mail Regular and Air Mail Postage. Air Mail Regular is a thick textured distressed font which contains a full character set. The postage font has a full array of mailing stamp ephemeral icons designed to decorate and embellish. There is nothing philosophical about either of these fonts, just have fun with them.

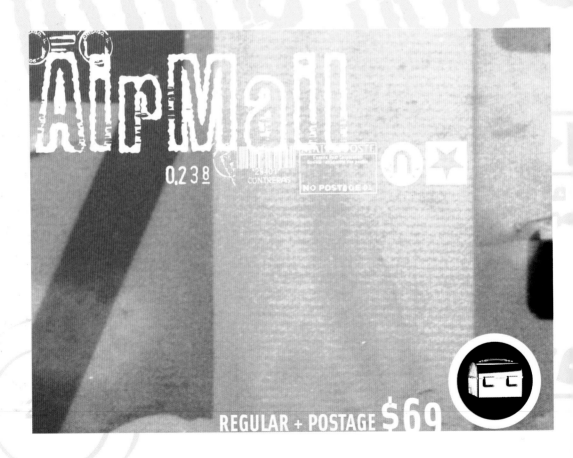

PURCHASE ONLINE AT: **http://www.lunchboxstudios.com**

Graphic Design ▷
Adam Roe

Purpose
**Promotional
Cover for
Pavement
Magazine**

Graphic Design ◁
Adam Roe

Purpose
**Air Mail Promo
Mailer**

URRICANE

PHOTOGRAPHY
TOM LEGOFF
TEXT BY
EDMUND HARRISON

Alembic

Font Name
Alembic

Font Families
Alembic
Regular One

Alembic
Regular Two

Alembic Regular Italic One

Alembic Regular Italic Two

Alembic Bold One

Alembic Bold Two

Alembic Bold Italic One

Alembic Bold Italic Two

Style
Experimental

Alpha Page
161

Font Designer, Rodrigo Cavazos *United States*

Alembic is an experimental typeface designed by Rodrigo Cavazos and published through his unique foundry, Psy/Ops. It is distinguished by its variably flattened bowls, interspersed ball terminals, and other uniquely unusual motifs. The family includes a range of alternate characters in auxiliary fonts that include: Regular One and Two, Italic One and Two, Bold One and Two, and Bold Italic One and Two.

Graphic Design
Rodrigo Cavazos

Purpose
Promotional Postcard for Alembic Typeface

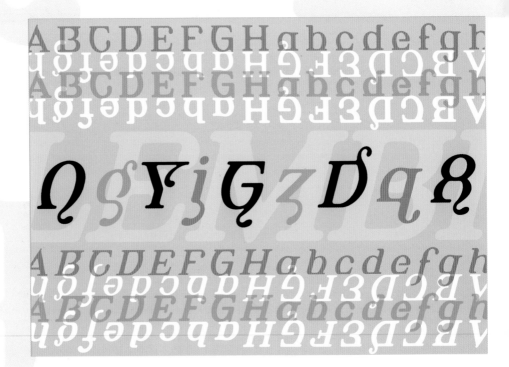

PURCHASE ONLINE AT: **http://www.psyops.com**

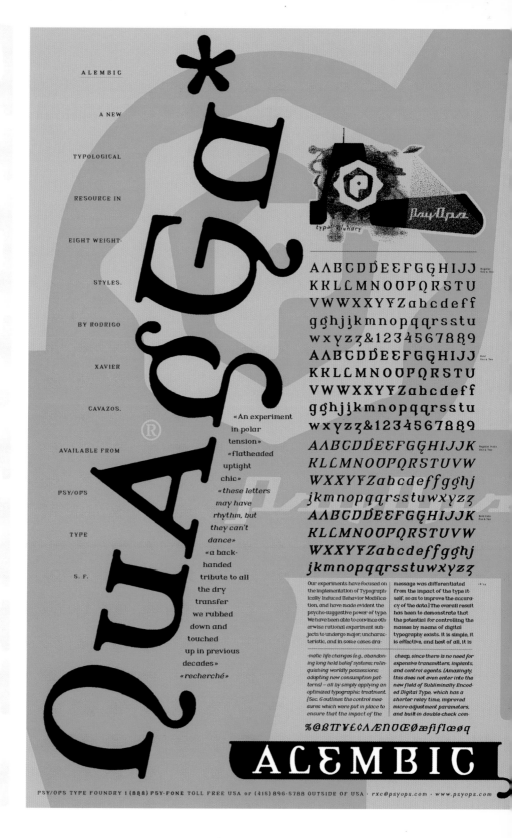

Graphic Design
Rodrigo Cavazos

Purpose
**Promotional
Postcard for
Alembic Typeface**

Alembic————

Font Name
Alien Hidden

Font Families

(Alien Hidden)

(Alien Grey)

Style
Experimental

Alpha Page
165

Graphic Design
Joshua Distler

Purpose
Postcard Artwork

Font Designer, Joshua Distler *United States*

The Alien Hidden typefont pushes the structure and readability of letterforms to its limits. Initially conceived as an experiment in the use of minimal elements to denote letterforms, the 3x3 matrix of dots optically blur together to form letterforms at small point sizes. The negative space defines the edges of the letterforms. When set at larger point sizes, the letterforms create a variety of graphic textures.

Graphic Design
Joshua Distler

Purpose
Postcard Artwork

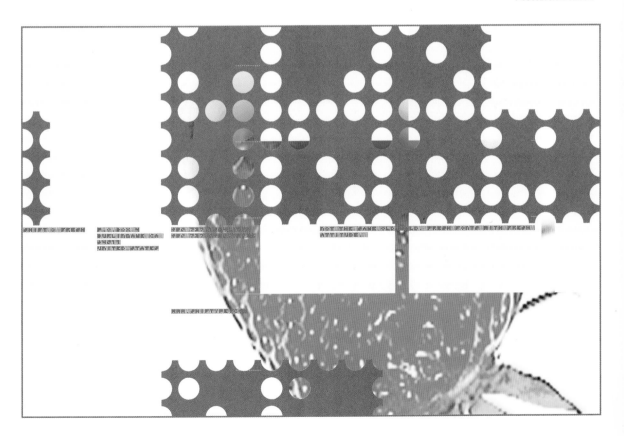

Anthropolymorphics

Font Name
Anthropolymorphics

Font Families
Anthropolymorphics 1.0
Anthropolymorphics 1.1
Anthropolymorphics 2.0
Anthropolymorphics 2.1

Style
Techno

Alpha Page
166

Font Designer, Matius Gerardo Grieck *England, UK*

Anthropolymorphics is derived from the synthesized fusion in name and meaning of Anthroposophy: the thinking which explores various metaphysical realms connected with human life through our conscious understanding; and Polymorphism: the ability to assume different forms, and the coexistence, in the same locality of individuals, within the same category or type. The system emphasizes single characters individual traits that, in combination, integrate as a whole, allowing further character distinctions in the capital K, lower a,j,k and r of the minimalized 2.0–2.1 sans versions.

Graphic Design
Matius Gerardo Grieck

Purpose
Digital Font Catalogue Presentation

Entering this new century we heard it all again, the belief that **reason and progress** will dispel prejudice and bring about **universal brotherly love**; obscuring the truth of **radical selfishness**, the tyranny of the strong over the weak, and a **dishonest** and **selfdeluding sentimentality**.

PURCHASE ONLINE AT: **http://www.plusism.com**

Graphic Design
Matius Gerardo Grieck

Purpose
Digital Font Catalogue Presentation

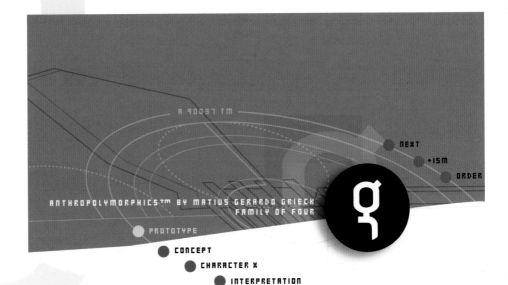

A 90037 TM

NEXT

+15M

ORDER

ANTHROPOLYMORPHICS™ BY MATIUS GERARDO GRIECK
FAMILY OF FOUR

g

PROTOTYPE

CONCEPT

CHARACTER X

INTERPRETATION

metaphysical | dimensions

manufacturing | *desire*

Anthropolymorphics

We should see a form of hope
in the rise of 'world stupidity'
as it must surely lead to a violent
reaction of some sort.

The future lies with so-called 'undeveloped'
societies, that have not bought into the
historical categories of humanism and reason.

Armature

Font Name
Armature

Font Families
Armature Light
Armature Regular
Armature Bold
Armature Extra
Bold

Style
Contemporary

Alpha Page
168

Graphic Design
Bob Aufuldish

Purpose
Postcard

PURCHASE ONLINE AT: **http://www.fontboy.com**

Font Designer, Bob Aufuldish *United States*

Armature is the result of an interest in typefaces that are constructed, rather than drawn. Although it is basically a monoline design, there are subtle details throughout that compensate for a monoline's evenness. As with all fontBoy fonts, there are dingbats hidden away in the dark recesses of the keyboard. When first designed, this face was called Dino—so the dingbats for Armature are dinosaurs.

Graphic Design
Bob Aufuldish

Purpose
Beyond the Margins of the Page Project

Armature

Ars Magna Lucis

Font Name
Ars Magna Lucis

Font Families
Ars Magna Lucis 1.0
Ars Magna Lucis 1.1

Style
Ornamental

Alpha Page
170

Font Designer, Matius Gerardo Grieck *England, UK*

Ars Magna Lucis is based on several cursive scripts of the late 17th century. They are synthesized to transform each character into an "hyperornament" in itself. Ars Magna Umbrae 2.0 is stroked throughout, emphasizing the act of erasing mistakes, as in handwriting to highlight them as an integral part of creation. Ars Magna Umbrae 2.1 goes further than the previous concept by incorporating a new typeface within, replacing the dominant focus and reinstating distinct legibility. Using the grave key, instead of the space bar, creates the semi-continuous stroke effect.

Graphic Design
Matius Gerardo Grieck

Purpose
Digital Font Catalogue Presentation

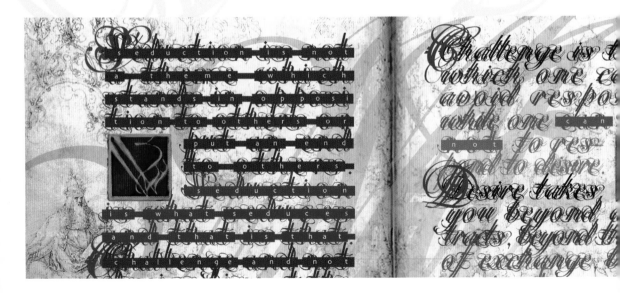

PURCHASE ONLINE AT: **http://www.plusism.com**

Graphic Design
Matius Gerardo Grieck

Purpose
Digital Font Catalogue Presentation

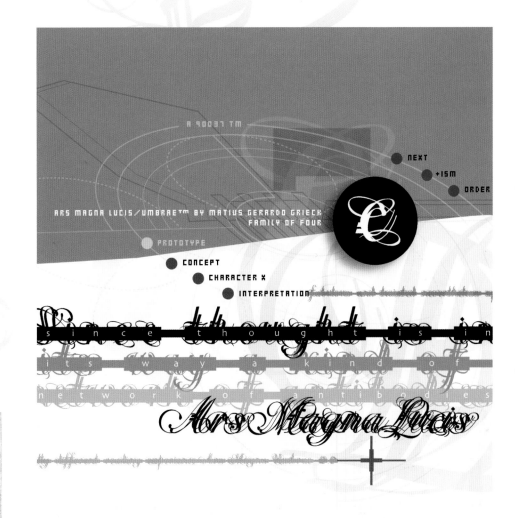

A 90037 TM

NEXT

+ISM

ORDER

ARS MAGNA LUCIS/UMBRAE™ BY MATIUS GERARDO GRIECK
FAMILY OF FOUR

PROTOTYPE

CONCEPT

CHARACTER X

INTERPRETATION

since thought is in
its way a kind of
network of antibodies

Ars Magna Lucis

Article 10

Font Name
Article 10

Font Families
Article 10 Regular
Article 10 Bold

Style
Contemporary
Distressed
Hand Drawn
NeoClassic
Ornamental

Alpha Page
172

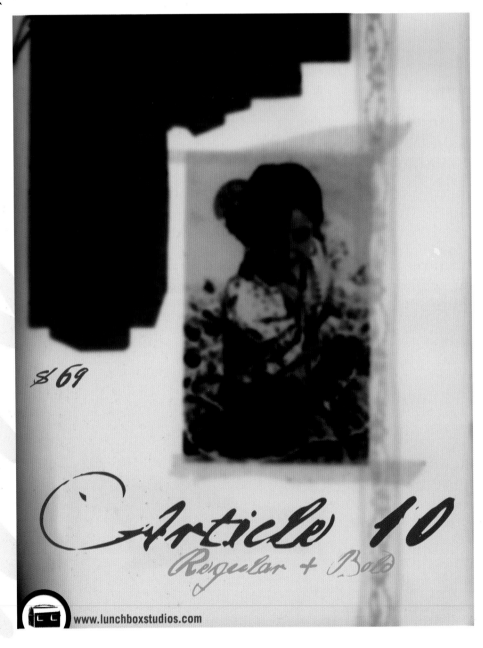

PURCHASE ONLINE AT: **http://www.lunchboxstudios.com**

Font Designer, Adam Roe

United States

Article 10 is a contemporary neoclassical typeface designed by Adam Roe, based on the actual Paris Peace Treaty of 1783. He had no idea what he was photographing, but he was attracted to the beautiful historic handwriting in the treaty. Roe developed the photos months later, and realized that an elegant original typeface was needed. He writes, "this becomes another of my rare contributions to historical typography. Perhaps this typefont will allow the designer to work with a piece of history. It lends itself to both progressive and classic typography, and is a musical font that can turn a grocery list into poetry. It appeals to all sides of Romanticism."

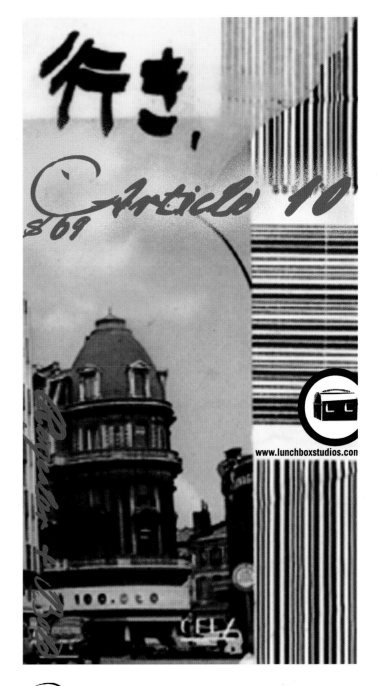

Graphic Design ▷
Mary Bergstrom

Purpose
Promo Mailer

Graphic Design ◁
Mary Bergstrom

Purpose
Promo Poster

Bad Eggs Bold

Font Name
Bad Eggs Bold

Style
Hand Drawn Stencil

Alpha Page
173

Font Designer, Swifty *England, UK*

Stencil fonts have always been an integral part of Typomatic/Swifty fonts. Bad Eggs Bold is a half stencil, half hand drawn font that makes a contemporary bold impression due to its thick appearance and thinly sliced letterforms. Bad Eggs Bold, created as a display font, is excellent for strap lines or headlines, and is legible, as small as nine point type.

Graphic Design ▷
Swifty

Purpose
Poster

Graphic Design ▽
Swifty

Purpose
Club Flyer

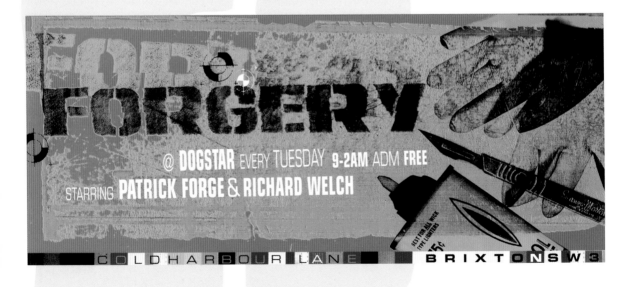

PURCHASE ONLINE AT: **http://www.swifty.co.uk**

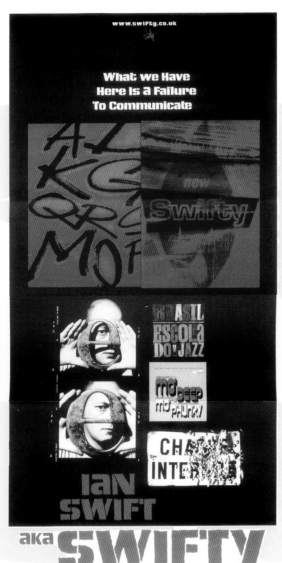

Bad Eggs Bold

B

BAUER TEXT INITIALS

Font Name
Bauer Text Initials

Style
NeoClassic

Alpha Page
173

Font Designer, Phil's Fonts Studio
United States

Bauer Text Initials is an elegant titling typeface. At its best when set very large, Bauer Text Initials demonstrates a powerful beauty. The delicate thin serifs are in contrast to the tall majuscule letterforms, creating a neoclassical balance. The typeface maintains its graceful features at smaller sizes where caps and small caps are utilized.

Graphic Design ▽
Tamye Riggs

Purpose
Typeface
Promotional
Postcard

Graphic Design ▷
Tamye Riggs

Purpose
Typeface
Promotional
Poster

PURCHASE ONLINE AT: **http://www.philsfonts.com**

GREEN
PEACE

BAUER TEXT INITIALS

B

BetaSans

Font Name
BetaSans

Font Families
BetaSans Normal
BetaSans Normal Oblique
BetaSans Bold
BetaSans Bold Oblique

Style
Contemporary

Alpha Page
174

Font Designer, Joshua Distler *United States*

BetaSans is a sans serif typeface which is geometric in nature. This contemporary font works well in both text and display applications. The Beta font series includes normal, bold, normal oblique, and bold oblique weights. Also included is a full accent set.

09 Alternate Rotor Maintenance Instructions

Calibrate rotor #02718 centerfuge *before* removing the powersupply housing. When engaged and locked correctly an audible beep tone will sound. If the winding core is rotated more than 180° a red status light will illuminate to indicate over rotation.

To prevent damage to the voltage regulator make sure that the flow regulator is set to limit to 12V and 75Hz. Initialization of the AFC will result in a reset of the flow regulator timing chip and settings. To reset the AFC and ROM settings, remove the ILIPC.

00-205.0

PURCHASE ONLINE AT: **http://www.shiftype.com**

03 Cruise Power

06 Hot Shut Down

02 Normal Engine Start

05 Hot Throttle-Up

04 Hot Engine Start

07 Idle

08 Rotor Maintenance Instructions

Calibrate rotor #02716 centerfuge *before* removing the powersupply housing. When engaged and locked correctly an audible beep tone will sound. If the winding core is rotated more than 270° a yellow status light will illuminate to indicate over rotation. *To prevent damage to the voltage regulator* make sure that the flow regulator is set to limit to 14V and 60Hz. Initialization of the AFC will result in a reset of the flow regulator timing chip and settings. To reset the AFC and ROM settings, remove the ILIPC.

00-136.2

Graphic Design ◁
Joshua Distler

Purpose
Type Sample
Card Concepts

Graphic Design ▷
Joshua Distler

Purpose
Type Sample
Card Concepts

BetaSans

BLINDDATE

Font Name
Blinddate

Font Families
BLINDDATE
LIGHT
BLINDDATE
REGULAR

Style
Contemporary
Experimental
Ornamental
Techno

Alpha Page
176

Graphic Design
Adam Roe

Purpose
Promo Poster

Font Designer, Adam Roe *United States*

Blinddate was built as a futuristic typeface yet uses softer more rounded forms familiar in today's typefaces. The shapes of Blinddate were subtle abstractions of typical letter forms, clearly based on a common theme. Making them appear worn and smooth gives them an approachability and use beyond typical futuristic fonts. Blinddate has been seen in a different settings worldwide and has been unpredictably the most successful Lunchbox typeface.

Graphic Design
Adam Roe

Purpose
Promo Mailer

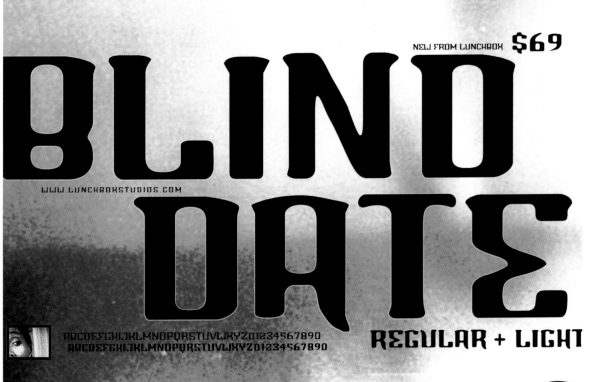

NEW FROM LUNCHBOX **$69**

BLIND DATE

WWW.LUNCHBOXSTUDIOS.COM

ABCDEFGHIJKLMNOPQRSTUVWXYZ01234567890
ABCDEFGHIJKLMNOPQRSTUVWXYZ01234567890

REGULAR + LIGHT

BLINDDATE

Bodoni Open

Font Name
Bodoni Open

Style
Ornamental

Alpha Page
177

Font Designer, Phil's Fonts Studio *United States*

A classic display face, Bodoni Open is a modern variation on the gorgeous historical type designs of Giambattista Bodoni. The elegantly cut letterforms convey a hint of delicacy, while exhibiting a strength and symmetry that is typical of Bodoni's style. Finely constructed, the open style letterforms give a slightly chiseled look and feel to the characters. This ornamental typeface is as elegant as it is strong.

Graphic Design ▽
Tamye Riggs

Purpose
Typeface
Promotional
Postcard

Graphic Design ▷
Tamye Riggs

Purpose
Typeface
Promotional
Poster

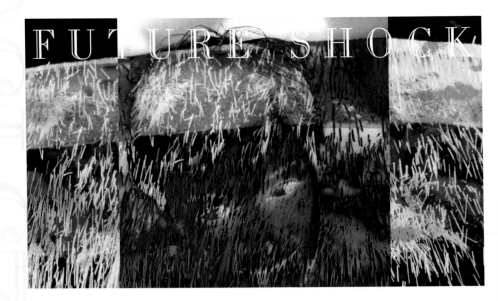

PURCHASE ONLINE AT: **http://www.philsfonts.com**

STORY OF O

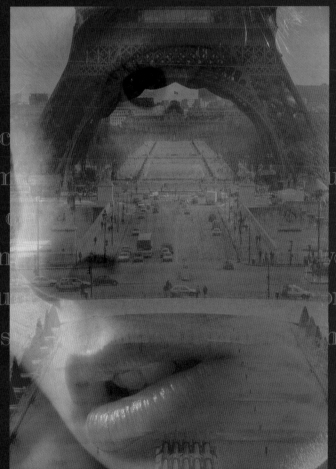

laisir, auc de son

urrait jam ur qu'el

manière liberté

la notion vec elle,

avait aucu on dans

laquelle, s mercher

PAULINE RÉAGE

Bodoni Open

Bokonon

Font Name
Bokonon

Style
Contemporary

Alpha Page
177

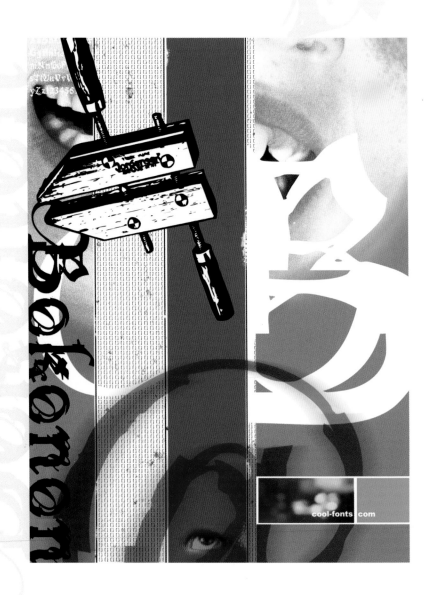

PURCHASE ONLINE AT: **http://www.cool-fonts.com**

Font Designer, Todd Dever *United States*

Bokonon is a futuristic font based on the mistakes of the past. It looks uniquely modern but strangely old. The organic characters are a blend of classic and textural contemporary letterforms. It is edgy enough to be grunge but elegant enough to monogram on a bathrobe.

Graphic Design ◁
Todd Dever

Purpose
Poster

Graphic Design ▷
Todd Dever

Purpose
Poster

Bokonon

Caslon Antiqua

Font Name
Caslon Antiqua

Style
Ornamental

Alpha Page
178

Font Designer, Phil's Fonts Studio *United States*

A display typefont with a sense of history, Caslon Antiqua maintains the appearance of early printed type. With its old-style flavor, yet somehow contemporary, distressed feel, Caslon Antiqua is suitable for a variety of applications. This ornamental font has classically constructed minuscules and majuscules, but includes a weathered look at the perimeter edges of the letterforms.

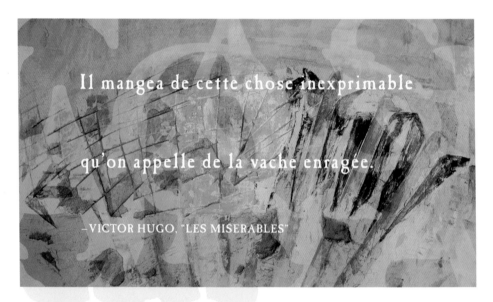

Il mangea de cette chose inexprimable

qu'on appelle de la vache enragée.

–VICTOR HUGO, "LES MISERABLES"

Graphic Design △
Tamye Riggs

Graphic Design ▷
Tamye Riggs

Purpose
Typeface
Promotional
Postcard

Purpose
Typeface
Promotional
Poster

PURCHASE ONLINE AT: **http://www.philsfonts.com**

FREEDOM AWAITS THOSE

WHO SHARE IN THE PAIN

OF A LIFE WITHOUT HOPE

fleet of souls

AND THE DAILY REFRAIN

OH, LORD

PLEASE STOP MY HUNGER

SHELTER ME FROM THE RAIN

—michael orzek

Lyrics to "Fleet of Souls" used with permission. Copyright ©1996 Michael Orzek

Caslon Antiqua

Cholla

Font Name
Cholla

Font Families
Cholla Sans Regular
Cholla Sans Bold
Cholla Slab Regular
Cholla Slab Bold
CHOLLA UNICASE
CHOLLA UNICASE LIGATURES

Style
Contemporary

Alpha Page
178

Graphic Design ▽
Sibylle Hagmann

Purpose
Cholla Typeface Promotion

Graphic Design ▷
Sibylle Hagmann

Purpose
Cholla Typeface Promotion

PURCHASE ONLINE AT: **http://www.emigre.com**

Font Designer, Sibylle Hagmann *United States*

The Cholla typeface family was designed by Sibylle Hagmann in 1998–99 and named after a species of cactus indigenous to the Mojave Desert. Cholla was originally developed for Art Center College of Design in Pasadena, California. Art director Denise Gonzales Crisp and associate designer, Carla Figueroa, collaborated with Hagmann to create a series of fonts that would offer numerous variations. The variety was needed to echo the school's nine different departments, yet together the fonts had to produce a unified feel.

Stylistically Hagmann set out to create a typeface family of 12 weights with slightly different personalities, reflecting the various concepts and ideas underlying their design. Cholla Sans Bold for example, isn't simply the Sans Regular with weight gain, but has bold letterforms with their own peculiar details. What all weights share and what is the necessary unifying detail is the tapered curve, marked out, in the lowercase b's left top and bottom of the bowl. Gonzales adds: "The forms appear classical as well. This combination could have a long life, and be timely. I also saw—at least in the beginnings of Cholla, hybrid forms, of human and machine growing together. These notions are appropriate for a school that teaches design and art."

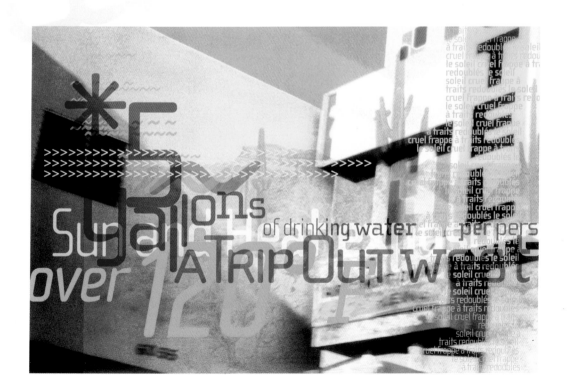

Cholla

ITC Coconino

Font Name
ITC **Coconino**

Style
Hand Drawn
Contemporary

Alpha Page
180

Font Designer, Slobodan Miladinov *Serbia*

"The initial impulse for creating this monostroked typeface," says Serbian designer Slobodan Miladinov," was the idea of translating certain auditory impressions into type, in this case, the surprising and confusing music of the Serbian hip hop musician Voodoo Popeye."

An art director in Belgrade, Yugoslavia, Miladinov created ITC Coconino™ using a freemouse technique with Adobe Illustrator's freehand drawing tool. Miladinov calls this a kind of pseudo-selflimiting computer calligraphy, which allows for a specific directness and immediacy in notation. Slobodan wanted to show a continuous transforming seriousness of tone from gravity via irony and burlesque to a completely idiotic tone through the medium of type. The strokes of ITC Coconino™ are simple and direct, each beginning and ending abruptly. The letters look playful, but in fact they are subtly disturbing.

Graphic Design ◁
Slobodan
Miladinov

Purpose
Catalog Cover for
Exhibition

Graphic Design ▷
Slobodan
Miladinov

Purpose
Exhibition Poster

ITC Coconino

Coltrane

Font Name
Coltrane

Style
Eclectic

Alpha Page
181

Graphic Design ▽
Swifty

Purpose
**Straight No
Chaser Magazine
Spread**

Graphic Design ▷
Swifty

Purpose
**Straight No
Chaser Magazine
Spread**

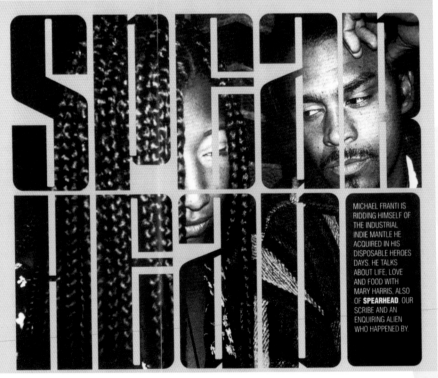

Font Designer, Swifty *England, UK*

Coltrane is a smooth, bold, black font that was inspired by classical jazz music of the 60s. With oversized proportions, and thin arms and eyes, this eclectic typeface is loud and powerful yet subliminally delicate. Coltrane portrays a rhythmic balance of thick and thin that is very legible as a display font; the bigger—the better!

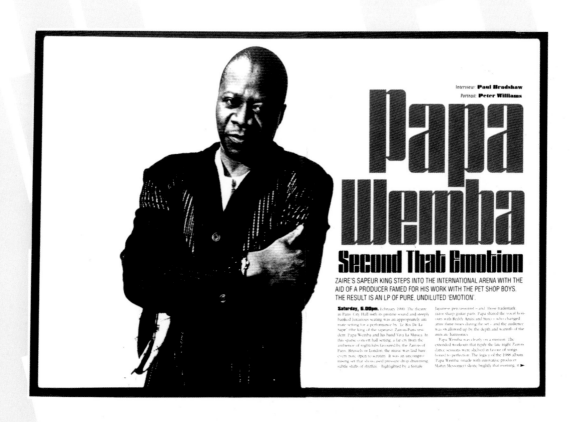

C

Cut It Out

Font Name
Cut It Out

Style
Stencil
Textural

Alpha Page
181

Font Designer, Swifty *England, UK*

Cut It Out is another stencil font from Typomatic/Swifty whose origin reflects the look of stamped packing crates. The decayed appearance reveals an aged, strong power with an attitude; perfect for that "military insignia" motif. The textural stenciled initials make it an excellent display or headline font.

Graphic Design ▽
Swifty

Purpose
Straight No Chaser Magazine Cover

Graphic Design ▷
Swifty

Purpose
Club Flyer

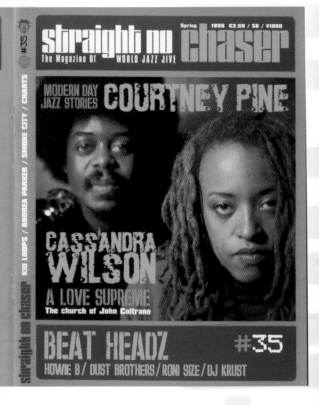

PURCHASE ONLINE AT: **http://www.swifty.co.uk**

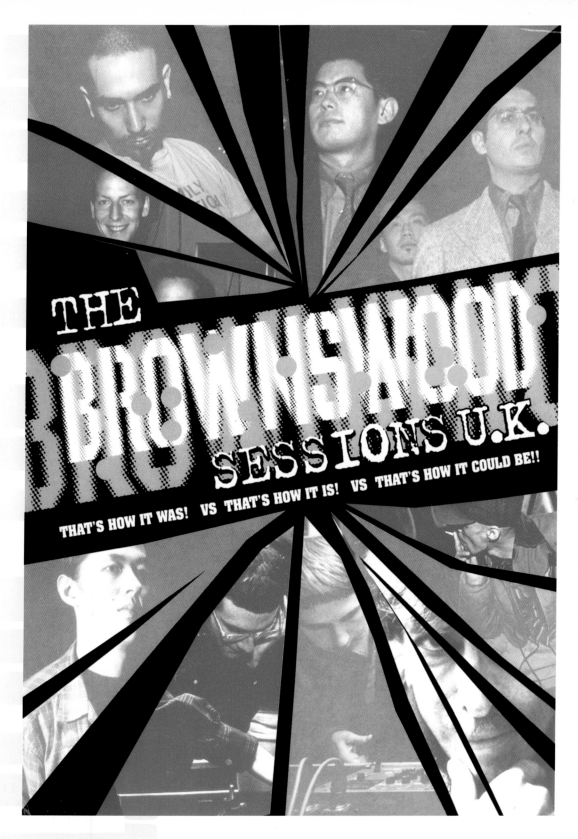

THE BROWNSWOOD SESSIONS U.K.

THAT'S HOW IT WAS! VS THAT'S HOW IT IS! VS THAT'S HOW IT COULD BE!!

D

FF Dax Condensed

Font Name
FF Dax
Condensed

Font Families
FF Dax Condensed
Light
FF Dax Condensed
Regular
FF Dax Condensed
Medium
FF Dax Condensed
Bold
FF Dax Condensed
Extra Bold
FF Dax Condensed
Black

Style
Contemporary

Alpha Page
182

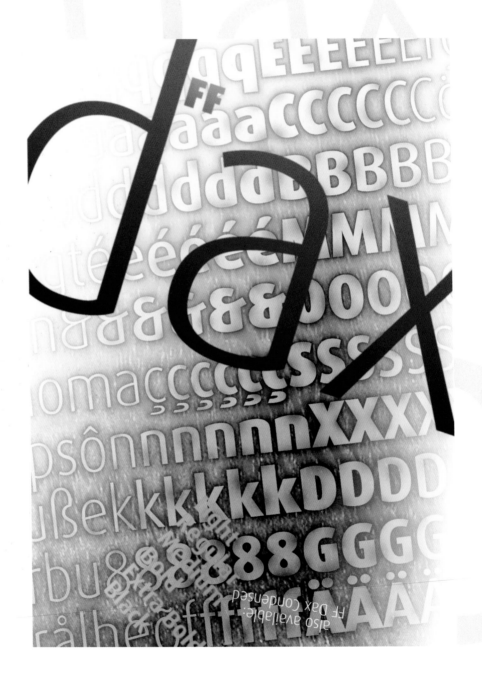

also available:
FF Dax Condensed

PURCHASE ONLINE AT: **http://www.fontfont.com**

Font Designer, Hans Reichel

Germany

FF Dax Condensed, designed by Hans Reichel, was developed by combining the clarity of a narrow Futura with a "slightly Roman touch" to make a space-saving but very legible typeface of timeless design. Very distinctive of this typeface are the missing spurs in the d, g, m, n, p, q, r and u. The family grew quickly to include the wider, but still narrow, FF Dax and FF Dax Italic. FF Dax Wide is less space-saving than its predecessors but still on the slender side. And is in keeping with tradition, available in six weights: Light, Regular, Medium, Bold, Extra Bold and Black. The logical next step for the successful FF Dax family was FF Dax Caps, available as of October 2000, from FontShop International.

Graphic Design ◁
Hans Reichel

Purpose
**Postcard for FSI
Font Promotion**

Graphic Design ▷
**C. Günther
W. Hellmann**

Purpose
Book Cover

WOLFGANG BORCHERT
Draußen vor der Tür
Mit einem Nachwort von HEINRICH BÖLL

roroto

FF Dax Condensed

D

Font Name
Default Gothic

Font Families
Default Gothic
A Gauge Upright

Default Gothic
A Gauge Italic

Default Gothic
B Gauge Upright

Default Gothic
B Gauge Italic

Default Gothic
C Gauge Upright

Default Gothic
C Gauge Italic

Style
Contemporary

Alpha Page
185

Default Gothic

Font Designer, Rodrigo Cavazos *United States*

Default Gothic is an original sans serif font with the look and feel of a terminal or OCR font—except that it features proportional spacing, and more styling than usual. Designed by Rodrigo Cavazos, Default Gothic has a tall x-height and an open, super-elliptical construction that makes it easy to read in small sizes. This contemporary font is available in three weights with corresponding italics that include: A Gauge Upright and Italic, B Gauge Upright and Italic, and C Gauge Upright and Italic.

Graphic Design
Bryan Ranzenberger,
Rodrigo Cavazos

Purpose
Promotional
Postcard for Default
Gothic Typeface

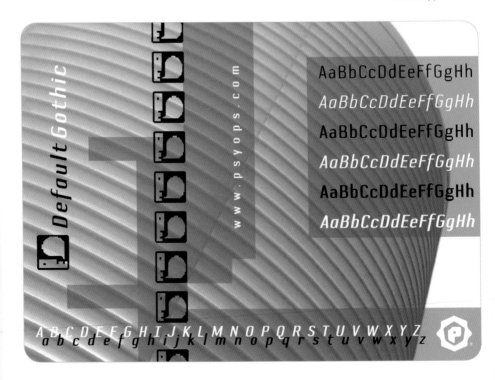

PURCHASE ONLINE AT: **http://www.psyops.com**

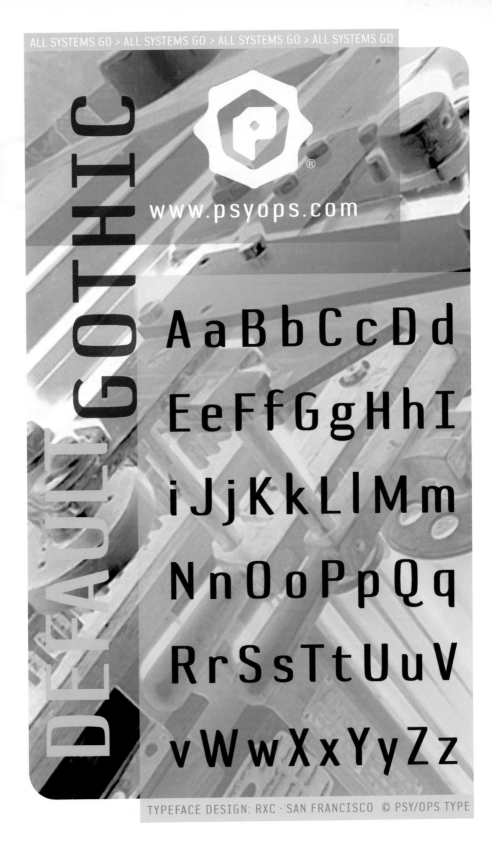

www.psyops.com

DEFAULT GOTHIC

AaBbCcDd
EeFfGgHhI
iJjKkLlMm
NnOoPpQq
RrSsTtUuV
vWwXxYyZz

TYPEFACE DESIGN: RXC · SAN FRANCISCO © PSY/OPS TYPE

Graphic Design
Rodrigo Cavazos

Purpose
**Promotional
Poster for Default
Gothic Typeface**

Default Gothic

D

Font Name
Duchamp

Style
Distressed

Alpha Page
188

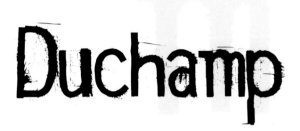

Duchamp

Font Designer, Fabrizio Gilardino *Canada*

Fabrizio Gilardino designed this typeface named after French Dadaist artist Marcel Duchamp in appreciation for his particular work and ideas. The first of four typefaces called Duchamp, was complete in February, 2000. The remaining three weights Bloody Dirty, Clean and Almost Too Clean soon followed. This typeface reflects a few of Gilardino's obsessions with the ideas of noise, pollution and hybridism. Gilardino wanted to create a noisy and polluted version of Letter Gothic, that could still be extremely legible and easy to use.

Characters from Letter Gothic have been printed, rubbed with sandpaper, cut and re-pasted together with adhesive tape. Serifs have been added randomly by hand, for example; upper case A, R, Y or lower case b, t, v. The weight has also been altered, once again, in the same way; lower case I or upper case E or the number 7. The resulting characters have been scanned and re-worked in Photoshop before being imported into Fontographer.

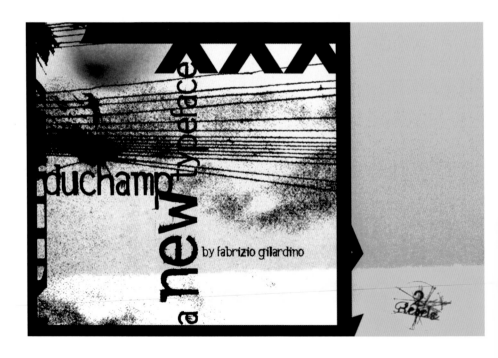

PURCHASE ONLINE AT: **http://www.2rebels.com**

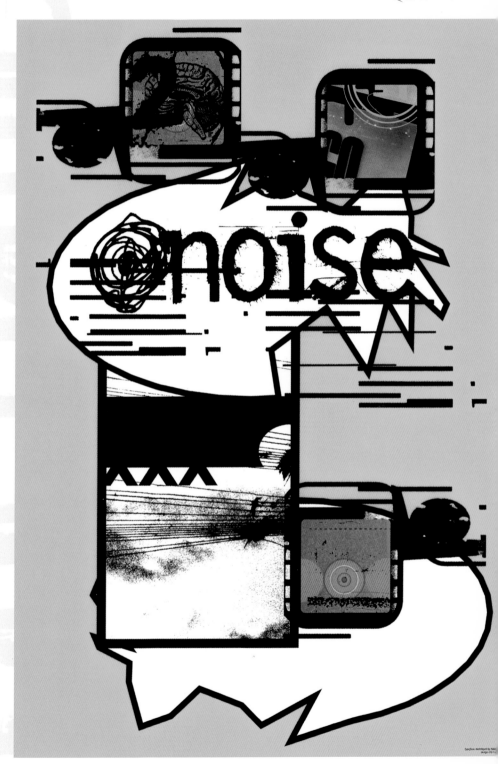

Graphic Design ◁
2Rebels

Purpose
**Duchamp Postcard
Banner**

Graphic Design ▷
2Rebels

Purpose
Exhibition Poster

Duchamp

Font Name
DV9

Style
Distressed

Alpha Page
188

Font Designers, Marie-France Garon, Fabrizio Gilardino *Canada*

DV9 is a collaborative typeface designed by Fabrizio Gilardino and Marie-France Garon. Printed characters from an existing font were shot with a digital camera and then recorded on the computer using the fast forward movement. Their goal was to give the typeface a kind of fragmented look and to convey the ideas of movement and speed. By keeping the amount of "external interferences" (spots, stains, scratches) to a minimum, the font is legible in large, as well as, small sizes.

a new typeface

by marie france garon + fabrizio gilardino

Graphic Design ▷
2Rebels

Purpose
**2Rebels Exhibition
Poster**

Graphic Design ◁
2Rebels

Purpose
DV9 Postcard Card

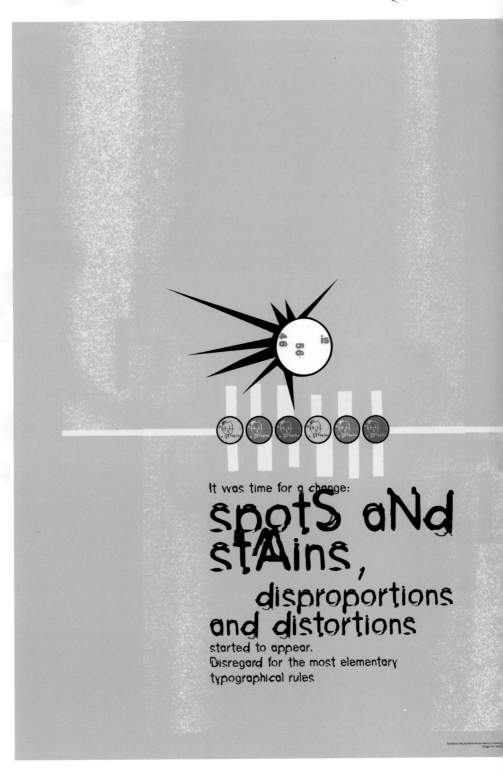

It was time for a change:
spotS aNd
stAins,
disproportions
and distortions
started to appear.
Disregard for the most elementary
typographical rules

Eidetic Neo

Font Name
Eidetic Neo

Font Families
Eidetic Neo Regular

Eidetic Neo Italic

Eidetic Neo Bold

Eidetic Neo Bold Italic

Eidetic Neo Black

Eidetic Neo Smallcaps

eidetic neo omni

Eidetic Neo Fractions ¾ ⅜ ⅝

Style
NeoClassical

Alpha Page
189

Eidetic REGULAR

Eidetic ITALIC

Eidetic BOLD

Eidetic BOLD ITA

Eidetic BLACK

eidetic OMNI

Eidetic SMALLCAPS

PURCHASE ONLINE AT: **http://www.psyops.com**

Font Designer, Rodrigo Cavazo, *United States*

Eidetic Neo, designed by Rodrigo Cavazos has a traditional foundation, balanced non-classical proportions, and subtle traces of deconstruction. This NeoClassical font features distinctive italics; and many alternate glyphs (including a www ligature), and variants. The typeface is available exclusively through Emigre Inc. and Psy/Ops. A sans serif counterpart, Eidetic Modern, is also available through Psy/Ops.

Graphic Design ◁
Rodrigo Cavazos

Purpose
Promotional Poster Image for Eidetic Neo Typeface

Graphic Design ▷
Rodrigo Cavazos

Purpose
Proposed Cover for Specimen Booklet

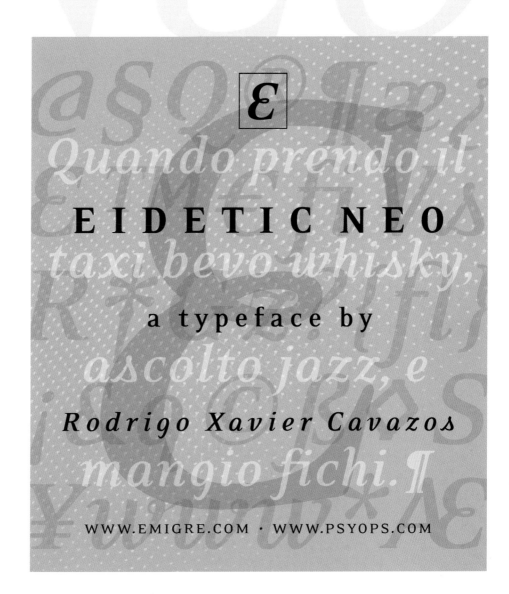

Eidetic Neo

Font Name
Epicure

Font Families
Epicure Regular
Epicure Alternate

Style
Experimental
Hand Drawn
Organic
Ornamental

Alpha Page
193

Font Designer, Adam Roe

United States

Designed by Adam Roe, Epicure is an experimental hand-drawn typeface based on the pre-Bauhaus concepts of Lyonel Feininger, a Bauhaus master of the 1920s. This eclectic ornamental font merges restricted geometry, hand craftsmanship, and technology with the expressiveness of medieval romanticism. Each letter is individually stylized, yet the design maintains an organic constancy. Epicure predates the mechanical monotony of later Bauhaus typefaces but retains the essence of the movement: much like an older, more rebellious brother. Epicure is one of the most amusing fonts Roe has designed.

Graphic Design ◁
Adam Roe

Purpose
Video Game Box

Graphic Design ▷
Adam Roe

Purpose
**Pavement
Magazine Cover**

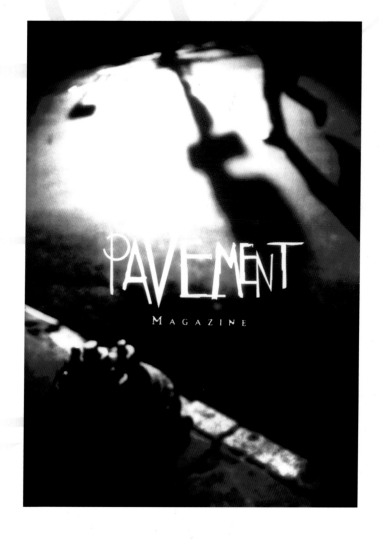

EricsSome

Font Name
EricsSome

Font Families
EricsSome Normal
EricsSome Pi

Style
Experimental

Alpha Page
194

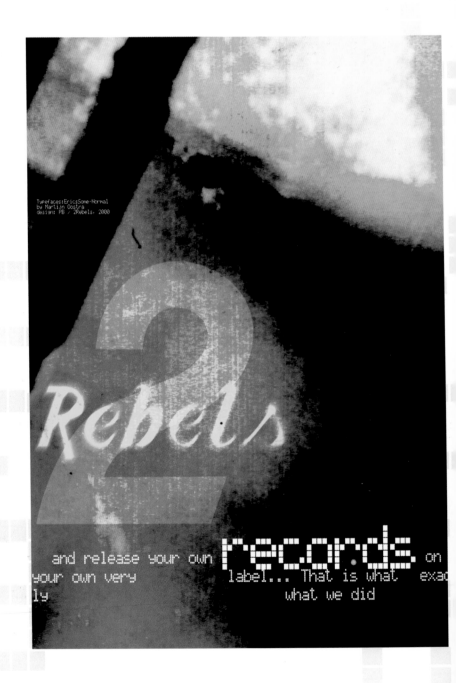

Typeface:EricsSome-Normal
by Martijn Oostra
design: PB / 2Rebels, 2000

and release your own **records** on
your own very label... That is what exac
 ...ly what we did

PURCHASE ONLINE AT: **http://www.2rebels.com**

Font Designer, Martijn Oostra

Netherlands

Martijn Oostra designed EricsSome after being commissioned to create an Ericsson cellular phone advertisement for Hagemeyer, a Dutch international holding magazine. Unable to find the exact font that resembled the dot matrix type found on the mobile phones, Oostra modeled a new typeface after the digital display type used on the Ericsson phone in the advertisement.

Graphic Design ◁
2Rebels

Purpose
**2Rebels Exhibition
Poster**

Graphic Design ▷
2Rebels

Purpose
EricsSome Banner

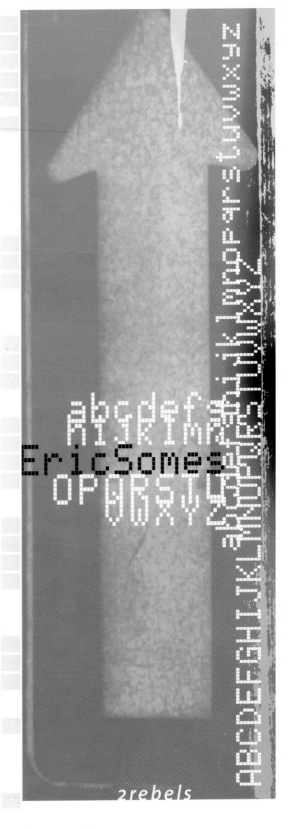

F

Font Name
Faceplate Sans

Font Families
Faceplate Sans
A Gauge Upright

Faceplate Sans
A Gauge Oblique

Faceplate Sans
B Gauge Upright

Faceplate Sans
B Gauge Oblique

Faceplate Sans
C Gauge Upright

Faceplate Sans
C Gauge Oblique

Style
Contemporary

Alpha Page
195

Faceplate Sans

Font Designer, Rodrigo Cavazos *United States*

Faceplate, designed by Rodrigo Cavazos, is a sans serif typeface featuring minimal contrast, and a rigid framework with slightly bowed diagonal stems intended to conserve column space without breaking form. Flexed terminals and expressive tail strokes distinguish this design from other contemporary sans serifs. The typeface is available in three weights with corresponding obliques: A Gauge Upright and Oblique, B Gauge Upright and Oblique and C Gauge Upright and Oblique.

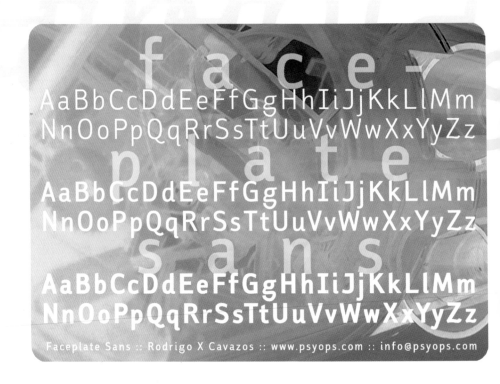

AaBbCcDdEeFfGgHhIiJjKkLlMm
NnOoPpQqRrSsTtUuVvWwXxYyZz

AaBbCcDdEeFfGgHhIiJjKkLlMm
NnOoPpQqRrSsTtUuVvWwXxYyZz

AaBbCcDdEeFfGgHhIiJjKkLlMm
NnOoPpQqRrSsTtUuVvWwXxYyZz

Faceplate Sans :: Rodrigo X Cavazos :: www.psyops.com :: info@psyops.com

PURCHASE ONLINE AT: **http://www.psyops.com**

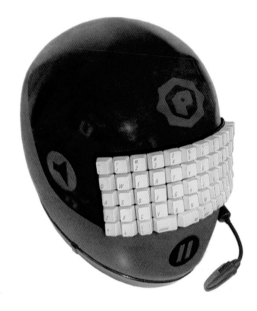

Graphic Design ◁
Rodrigo Cavazos

Purpose
**Promotional
Postcard for
Faceplate Sans,
intended to
emphasize the
visual transparency
of the design**

Graphic Design ▷
Rodrigo Cavazos

Purpose
**Promotional
Postcard for
Faceplate Sans**

PSY/VAC_M620i
interface › redefined

INTRODUCING THE PSY/VAC_M620i
PSY/OPS' breakthrough Integrated SuperCranial
Processing Appliance. Featuring on-board physi-
ognamatic key module, Obsolescence Resistant
Operating System, twin gamma shielding, advanced
anti-seizure algorythms, neurometric auro/vocal
resonance gaskets, auto-regulating comfort liner,
Faceplate Sans terminal typeface, and much more.
Available in six attractive color schemes, with
candyapple finish. DOT & SNELL APPROVED.

FEATURING FACEPLATE SANS
ABCDEFGHabcdefgh
ABCDEFGHabcdefgh
ABCDEFGHabcdefgh

www·psyops·com

Faceplate Sans

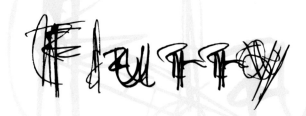

Font Name
Flurry

Font Families
Flurry Normal
Flurry Heavy
Flurry Black

Style
Experimental

Alpha Page
198

Font Designer, Peter Kin-Fan Lo *China*

Flurry is an experimental script font, ideal for display purposes, that breaks fundamental rules and theories in type design. Designer Peter Lo created each character in a carefree, unconscious manner, resulting in abstract and unpredictable letterforms. Flurry's vigorous, free-flowing strokes and dots project a violent and energetic personality. Flurry comes in three wild weights, Flurry Normal, Flurry Heavy and Flurry Black.

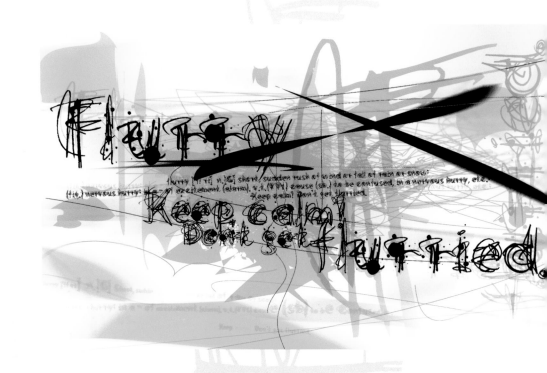

PURCHASE ONLINE AT: **http://www.garagefonts.com**

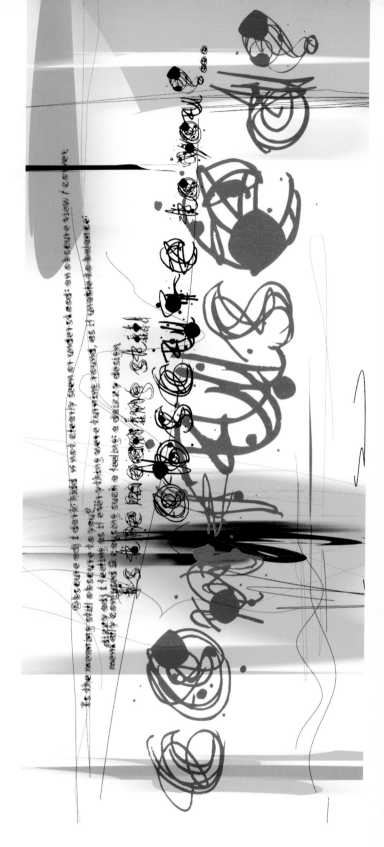

Graphic Design ▷
Peter Kin-Fan Lo

Purpose
**Typeface
Promotional
Flyer**

Graphic Design ◁
Peter Kin-Fan Lo

Purpose
**Typeface
Promotional
Poster**

Fono

Font Designer, Thomas Schnäbele *Germany*

Designed for display applications, Fono is a distinctive alternative to more traditional sans serif designs. Designer Thomas Schnäbele's inspiration for this rounded typestyle was the soft appearance of type printed on interfaces such as, frequency scales. The shapes consist of free and circled roundings in the Medium members, and free and elliptical roundings in the Expanded and Compressed variants. The different weights are designed to create versatile mixes, even within a single word.

CROSS CURRENTS
RANDAL CORSEN/RANDY WINTERDAL/ONNO WITTE
with special guests GERARDO ROSALES and IZALINE CALISTER

SUNÚ

PURCHASE ONLINE AT: **http://www.garagefonts.com**

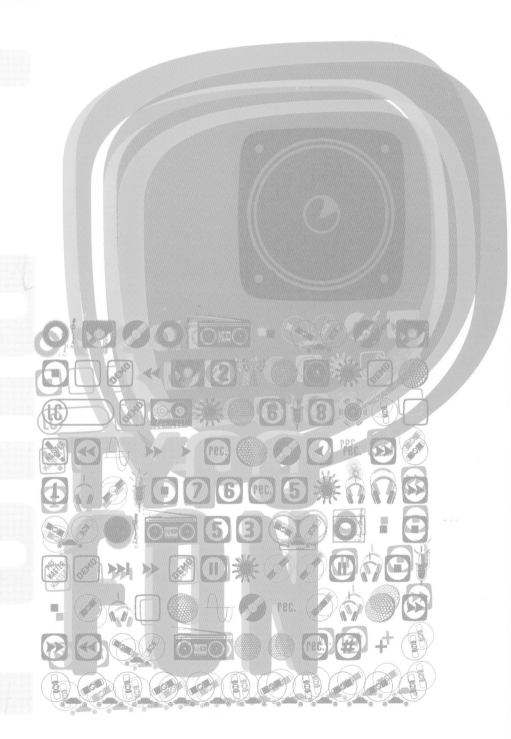

Graphic Design ▷
Thomas
Schnäbele

Purpose
Typeface
Promotional
Poster

Graphic Design ◁
Thomas
Schnäbele

Purpose
CD Cover

Freak

Font Name
Freak

Style
Hand Drawn

Alpha Page
206

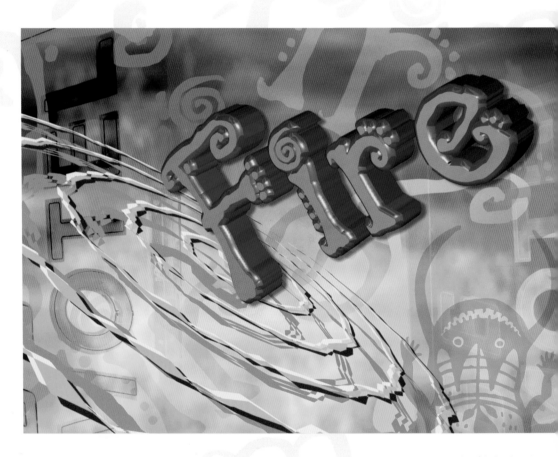

Graphic Design △
Todd Dever

Purpose
Experimental

PURCHASE ONLINE AT: **http://www.cool-fonts.com**

Font Designer, Todd Dever *United States*

Freak, a hand drawn font designed by Todd Dever of Cool Fonts, was created exclusively on the computer using Fractal Design Painter™. It has a whimsical feel that is loose and playful. Serifs curl around in oddly shaped spirals with an accent of little dots on some of the letterforms. According to HOW magazine, it has been one of the most popular designer fonts on the web. In addition, the New York Times featured this font in its article on new type designers.

Graphic Design ▽
Todd Dever

Purpose
Experimental

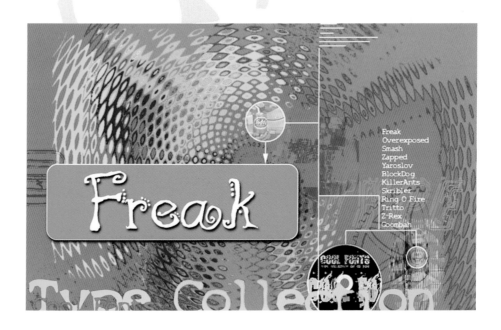

Freak
Overexposed
Smash
Zapped
Yaroslov
BlockDog
KillerAnts
Skribler
Ring O Fire
Tritto
Z-Rex
Goombah

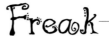

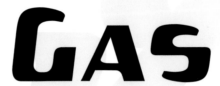

Font Name
Gas

Font Families
Gas
Gas Lite

Style
Contemporary

Alpha Page
206

Font Designer, Peter Bruhn *Sweden*

Peter Bruhn was inspired to design Gas by exotic food signage around his old neighborhood. This hybrid retro font is a mix of a 60s logo and a 70s futuristic font. The fluid letterforms flow together in an organic fashion as a funky display font. Gas has some extra surprise characters hidden inside, as well. There are two weights for this font, Gas and Gas Lite.

Graphic Design ▽
Peter Bruhn

Graphic Design ▷
Peter Bruhn

Purpose
Typeface
Promotion

Purpose
Typeface
Promotion

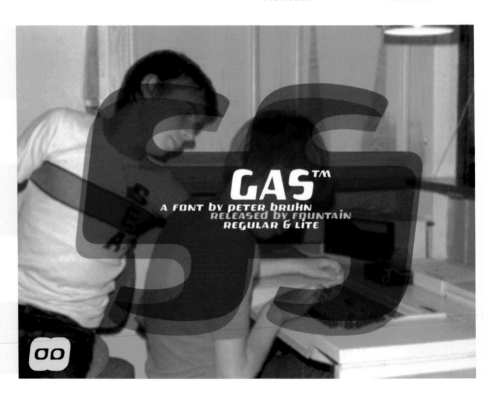

PURCHASE ONLINE AT: **http://www.fountain.com**

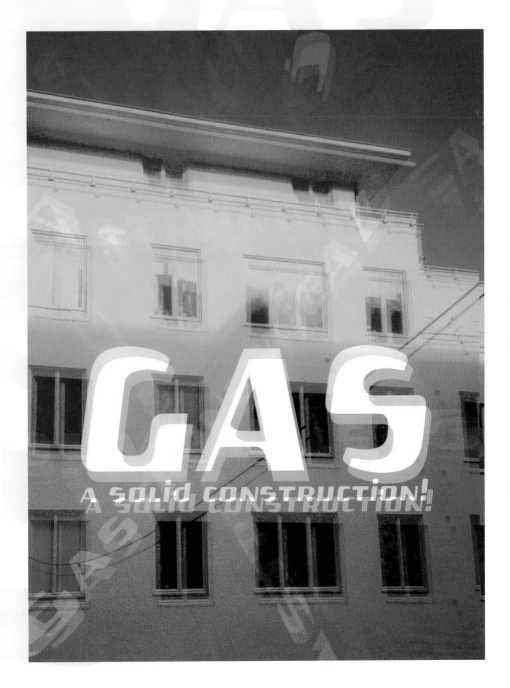

GAS
A SOLID CONSTRUCTION!

GAS ———

GUNSHOT

Font Name
Gunshot

Style
Experimental

Alpha Page
207

Graphic Design
Swifty

Purpose
**Straight No
Chaser Magazine
Spread**

Palm Skin Productions

After a string of Mo Wax singles, maverick percussionist Simon Richmond took his Palm Skin outfit from the That's How It Is sessions to Neneh Cherry's new album. He's now set to release "Remilixir" his first LP on Hut Recordings ►

PURCHASE ONLINE AT: **http://www.swifty.co.uk**

Font Designer, Swifty *England, UK*

Gunshot was developed from an old sign which had been shot with an actual shotgun. The pellet holes are real but were digitally enhanced during the construction of the typeface. This bold font is a supreme choice for headlines that are meant to send a powerful message that is not easily forgotten.

Graphic Design
Swifty

Purpose
Straight No Chaser Magazine Spread

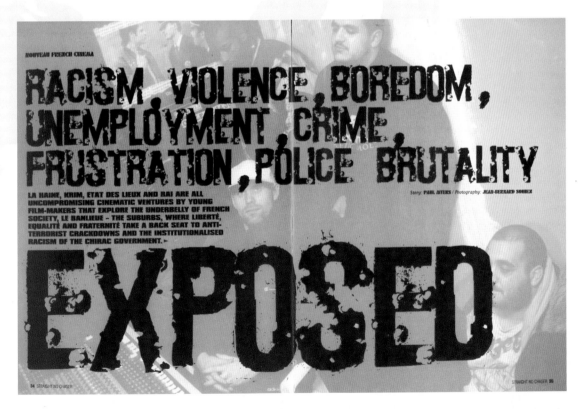

GUNSHOT

Hattrick

Font Name
Hattrick

Font Families
Hattrick Regular
Hattrick Italic
Hattrick Small
Caps & Old Style
Figures
Hattrick Bold
Hattrick Bold Italic

Style
Contemporary

Alpha Page
208

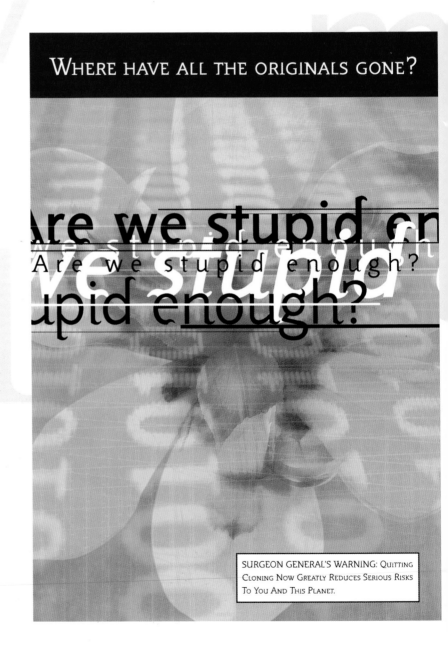

WHERE HAVE ALL THE ORIGINALS GONE?

Are we stupid en
Are we stupid enough?
stupid
upid enough?

SURGEON GENERAL'S WARNING: QUITTING
CLONING NOW GREATLY REDUCES SERIOUS RISKS
TO YOU AND THIS PLANET.

Font Designer, Stefan Hattenbach *Sweden*

Hattrick was designed by Stefan Hattenbach to create an interesting combination between a sans and a serif font. While this concept is not unique, most sans serif hybrid fonts lean heavily toward display styles, or have insufficient weights. The designer set out to produce a style for both text and display purposes. Hattrick's name was inspired by the design's "trick" with the "cat's claw." This unique twist adds a highly personal touch to Hattrick, one of Hattenbach's goals when designing typefaces.

Graphic Design ◁
Stefan Hattenbach

Purpose
Typeface
Promotional
Postcard

Graphic Design ▷
Stefan Hattenbach

Purpose
Typeface
Promotional
Postcard

Hattrick

ITC Humana

Font Name
ITC **Humana**

Font Families
Humana Serif
Medium ITC

*Humana Serif
Medium Italic ITC*

Humana Serif
Light ITC

*Humana Serif Light
Italic ITC*

**Humana Serif
Bold ITC**

***Humana Serif
Bold Italic ITC***

Humana Script Medium ITC

Humana Script Light ITC

Humana Script Bold ITC

Humana Sans
Medium ITC

*Humana Sans
Medium Italic ITC*

Humana Sans Light ITC

*Humana Sans Light
Italic ITC*

**Humana Sans
Bold ITC**

***Humana Sans
Bold Italic ITC***

Style
Contemporary

Alpha Page
210

Graphic Design ▽
**Timothy
Donaldson**

Purpose
Font Promotion

Graphic Design ▷
**Timothy
Donaldson**

Purpose
Poster

PURCHASE ONLINE AT: **http://www.itcfonts.com**

Font Designer, Timothy Donaldson *England, UK*

British designer Timothy Donaldson, a self-taught type designer, began his career as a sign painter and gravitated to lettering and typeface design. He initially created the ITC Humana™ Script typeface with a broad-edged pen. Wondering what a corresponding Roman might look like, he made pencil sketches as a prelude to constructing letters on screen with font software. ITC Humana™ is an extended and versatile typeface family with an unusual array of variations. In all, the ITC Humana™ family offers 15 weights and styles (light, medium, and bold weights of a serif, sans serif and script design, with matching italics for the serif and sans serif) that give designers extensive flexibility. ITC Humana™ is well suited for use where clarity is important yet a certain friendliness is desired.

Text from a book about trees by linnea lundquist used with permission. © 2000

ITC Humana

Hydrous

Font Name
Hydrous

Font Families
Hydrous Normal
Hydrous Italic
Hydrous Bold
Hydrous Bold Italic
Hydrous Black
Hydrous Black Italic

Style
Contemporary

Alpha Page
218

Graphic Design ▽
Rodrigo Cavazos

Purpose
Promotional Postcard for Hydrous Typeface

Graphic Design ▷
Rodrigo Cavazos

Purpose
Header for Hydrous Specimen Poster

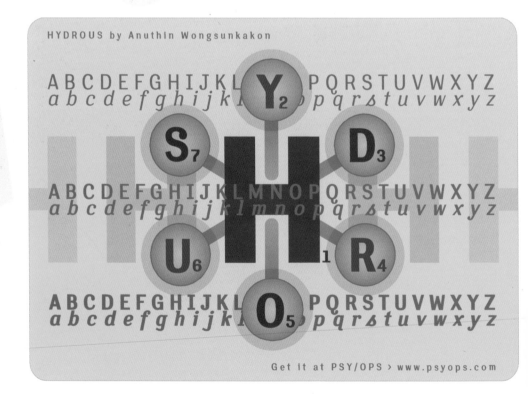

PURCHASE ONLINE AT: **http://www.psyops.com**

Font Designer, Anuthin Wongsunkakon *Thailand*

Hydrous, designed by Anuthin Wongsunkakon, is an industrial sans serif typeface which would be rather sterile, except that it integrates a ball terminal and other contemporary motifs that impart a sense of playfulness in the letterforms. The family consists of a wide range of weights: Hydrous Normal, Hydrous Italic, Hydrous Bold, Hydrous Bold Italic, Hydrous Black and Hydrous Black Italic.

HYDROUS

V7N/2V7*

San Francisco

www.psyops.com

* V=P 7=S N=Y 2=O

A B C a b c _ 1 2 3

A

Anuthin Wongsunkakon

Hydrous

Idiosynoptium

Font Name
Idiosynoptium

Font Families
Idiosynoptium 1.0
Idiosynoptium 1.5
Idiosynoptium 2.0

Style
NeoClassic

Alpha Page
221

Font Designer, Matius Gerardo Grieck *England, UK*

Idiosynoptium is loosely inspired by "Insular Majuscule," an early medieval script, without capitals, written by monks. This typefont has three basic concepts. The first is a non-linear system, in which each character retains its own idiosyncrasy but, set in word text, synthesizes as a whole. The second, preserves a metaphysical quality in a contemporary context. The third, employs irregular reversed majuscule and minuscule options. Idiosynoptium is a word comprising idiosyncratic, synoptic and scriptorium, reinterpreting the foundation of the concept.

Graphic Design
**Matius Gerardo
Grieck**

Purpose
**Digital Font
Catalogue
Presentation**

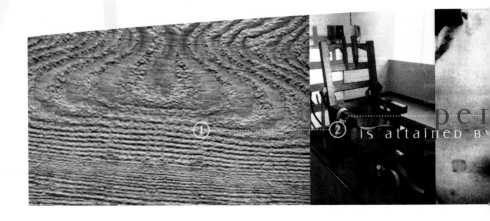

PURCHASE ONLINE AT: **http://www.plusism.com**

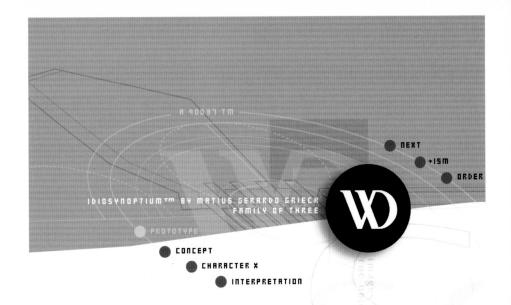

IDIOSYNOPTIUM™ BY MATIUS GERARDO GRIECK
FAMILY OF THREE

PROTOTYPE

CONCEPT
CHARACTER X
INTERPRETATION

Images have become our true sex object.
The object of our desire.

idiosynoptium
THE OBSCENITY
of our culture resides in
the confusion of
desire
materialized in the image.

Graphic Design △
**Matius Gerardo
Grieck**

Purpose
**Digital Font
Catalogue
Presentation**

idiosynoptium

I

Index

Font Name
Index

Font Families
Index Light
Index Light Italic
Index Book
Index Italic
Index Bold
Index Bold Italic
INDEX EXPERT
 BOOK
INDEX EXPERT ITALIC
**INDEX EXPERT
BOLD**
***INDEX EXPERT BOLD
ITALIC***
Index Book
Alternate
*Index Book
Alternate Italic*
Index Book
Ligature Italic
*Index Book
Ligature Italic*

Style
Contemporary

Alpha Page
222

Font Designers, Joshua Darden and Timothy Glaser *United States*

Index is an extensive monoline sans serif text typeface family, the product of countless hours of effort by co-designers Joshua Darden and Timothy Glaser. In addition to standard character sets, Index features a companion Typographer's Set and an Expert Set. The Expert Set contains optically-corrected small capital letters for use with lowercase text or subheadings. Unlike scaled-down capital letters, the "true small caps" are specifically drawn to complement the lowercase. The Typographer's Set includes 39 alternates to letters and punctuation found in the standard Index fonts, plus a schwa (upside-down e) and one archaic letter, the long s. There are also 49 ligatures, ranging from the historically accurate to the fanciful. A few superior capitals, with and without punctuation, are provided to construct the following honorifics: "Mr., Mrs., Ms., and Dr." (English); "Mr., Mrs., Ms., and Dr.," (British); "Messr., Mme., and Mlle." (French). In addition, superior capitals are provided for the Scottish name components "Mac and Mc," and the Abbreviation "No." Index was awarded First Place, Text Category, in the Garagefonts/Macromedia International Font Design Contest in 1997.

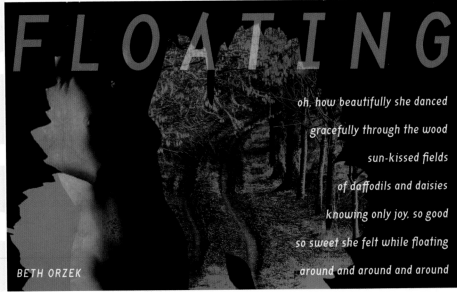

Lyrics to "Floating" used with permission. © 1996 Beth Orzek

PURCHASE ONLINE AT: **http://www.garagefonts.com**

da^MN, $(P)°t!

a

good glass in the
bishop's hostel

.:¡caveat empt{y)or!:,,

a closed mind? a(n)emptyglass!

in the devil's seat half full;
" ‡‡‡305))6°:4826)4‡. forty-one degrees and thirteen minutes
1)4‡);806°:48‡8960)) empty: perhaps we should call him
{ 85;1‡(;:‡ * haven't m back?
{ 8‡83(88)5 * northeast and by north main branch seventh limb
 ade ourse lves clear ?
{ ‡:46(:88°96°?:8)°‡(; EAST SIDE SHOOT FROM THE ˢᵉ‡ᵗ ᵉyᵉ of the death's-head
 a bee-line from the tree through the shot
{ 485):5°‡2:"‡(:4956°2 fifty feet out.
(5°−4)8¶8°:4069285 W H O
);)6‡8)4‡‡:1(‡9:48081:8:8‡1:48‡85:4)485‡528806°
{ Name) D(rank) (Number }
 we do apologize for
) my the delay: all agents 81(‡9:48:(88:4(‡?34:48)
) are still busy. 4‡:161::188:‡?:"
) pleas
) wHis eContinue to hold.

key?

Graphic Design ◁
Tamye Riggs

Purpose
Typeface
Promotional
Postcard

Graphic Design ▷
Joshua Darden

Purpose
Typeface
Promotional
Poster

Index

Inhumaine

Font Name
Inhumaine

Font Families
Inhumaine
Left
Inhumaine
Center
Inhumaine
Right
Inhumaine
Out Left
Inhumaine
Out Center
Inhumaine
Out Right

Style
Ornamental

Alpha Page
229

Font Designers, Roberto Brunetti and Pierluigi Portolano *Italy*

Inhumaine was inspired by the biker's world of the fifties and sixties, the atmosphere of several Russ Meyer films, and the design of the refrigerator located in co-designer Roberto Brunetti's childhood home. Roberto and design studio partner Pierluigi Portolano worked diligently to perfect the construction of Inhumaine. The type family features Left, Center and Right versions, affording the capability to mix and match the styles to achieve proper starting, ending and connecting points for every word. Inhumaine is well-suited for headlines, and useful for those who want to simultaneously express the aggressiveness of the biker's milieu and the poetry of the past.

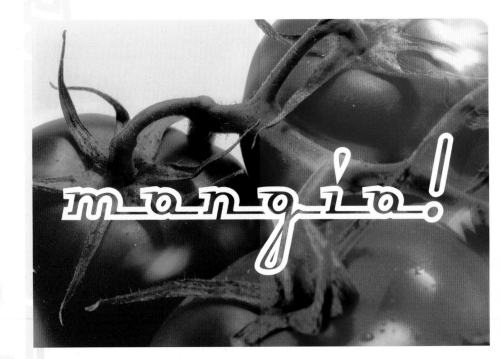

PURCHASE ONLINE AT: **http://www.garagefonts.com**

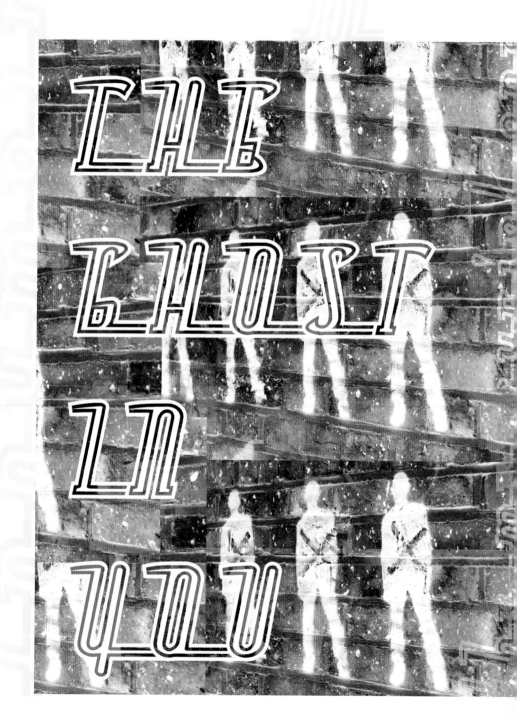

Graphic Design ◁
Tamye Riggs

Purpose
**Typeface
Promotional
Postcard**

Graphic Design ▷
Tamye Riggs

Purpose
**Typeface
Promotional
Poster**

Interrobang

Font Families
Interrobang
Sans Regular

Interrobang
Sans Bold

Interrobang
Sans Inline

Interrobang
Sans Italic

Interrobang
Serif Regular

Interrobang
Serif Inline

Style
Contemporary

Alpha Page
231

Font Designer, Jason Hogue *United States*

Intrigued by an obscure punctuation mark, the interrobang, designer Jason Hogue was inspired to create a type family honoring this under-appreciated and under-utilized letterform. The interrobang, a single character combining the exclamation point and the question mark, was introduced by Martin K. Speckter in 1962 in an article written for TYPEtalks Magazine. The new name was derived from the Latin for query and the proofreader's term for exclamation. Naming his type family after this character, Hogue included the interrobang symbol in each font. Fonts in the Interrobang family are excellent for both text and display applications, and may be layered to achieve unusual effects.

Graphic Design
Jason Hogue

Purpose
**Typeface
Promotional
Postcard**

what are you looking at?

THE PURVEYORS OF ADVERTISING INVENT AND DELETE WORDS IN THE ENGLISH LANGUAGE ON A WHIM, AND SO THEY DELETED A CHARACTER AS WELL. THE INTERROBANG HAS GONE FORGOTTEN SINCE IT'S INCEPTION IN THE SIXTIES, BUT IT IS TIME THAT THE INTERROBANG WAS REBORN. UP COMRADES, AND WE SHALL SAVE ITS SOUL!

6 WEIGHTS AVAILABLE FROM GARAGEFONTS.COM
DESIGNED BY JASON HOGUE OF NIGHTMARE DESIGNERS ©1999

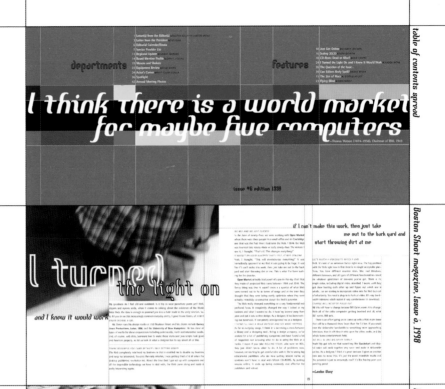

I think there is a world market for maybe five computers

—Thomas Watson (1874–1956), Chairman of IBM, 1943

issue #6 edition 1998

I turned the light on
and I knew it would work

if I can't make this work, then just take me out to the back yard and start throwing dirt at me

Just get Online

This is about survival
not whizzy technology.

Graphic Design
Jason and Katie Hogue

Purpose
Boston Shoot Magazine, Table of Contents

J

JEAN SPLICE

Font Name
Jean Splice

Font Families
JEAN SPLICE

JEAN SPLICE
LO LEFT

JEAN SPLICE
LO RIGHT

JEAN SPLICE
UP LEFT

JEAN SPLICE
UP RIGHT

Style
Experimental

Alpha Page
233

PURCHASE ONLINE AT: **http://www.cool-fonts.com**

Font Designer, Todd Dever

United States

The JeanSplice typefont system is a genetic anomaly. Each unique letterform character has another fused within it. There are four variations of the "normal" version. These variations have large spikes, which branch out in a particular direction (JeanSplice UpLeft, JeanSplice UpRight, JeanSplice LoLeft and JeanSplice LoRight). This typeface is a superbly designed typefont that allows a variety of custom designs by mixing the variations. The spikes and serifs blend to form an elegant yet eclectic typeface.

Graphic Design ◁
Todd Dever

Purpose
Experimental

Graphic Design ▷
Todd Dever

Purpose
Experimental

JEAN SPLICE

ITC Johanna Sparkling

Font Name
ITC **Johanna Sparkling**

Style
Hand Drawn

Alpha Page
236

Your most

affectionate Friend

& humble Servant

Johann

Sparkling,

ITC.

Font Designer, Viktor Solt *Austria*

ITC Johann Sparkling™ is reminiscent of the educated handwriting of the 18th century. Vienna designer, Viktor Solt intended to close the gap between highly formal copperplate scripts and the scribbled look of true handwriting. Solt is not much interested in highly formal and perfect calligraphy but in quick, personal looking scripts. He usually starts with some historic samples and is not trying to copy these sources but rather to incorporate them into his own handwriting. It takes up to two weeks and many sheets of paper until the respective script becomes his own. "Of course this would not be an economic approach to individual lettering jobs," says Silt, "but I can conserve the custom script for future use by digitizing it." ITC Johann Sparkling™ appears much smaller than its nominal point size, so it's best used in larger type.

The ornate swash caps are never meant to be used together, only with the lowercase.

Graphic Design ◁
Viktor Solt

Purpose
Johanna
Sparkling
Promotional
Poster for ITC

Graphic Design ▷
Viktor Solt

Purpose
Book Cover

KAY DREYFUS
MARGARETHE ENGELHARDT-KRAJANEK
BARBARA KÜHNEN

Die Geige war ihr Leben

Drei Frauen im Portrait

FRAUENTÖNE 4

4/4 verlag

Killer Ants

Font Name
Killer Ants

Font Families
Killer Ants
Killer Ants Bold

Style
Grunge

Alpha Page
236

Font Designer, Todd Dever *United States*

Killer Ants, created by Todd Dever of Cool Fonts, is grunge to the max. The font has two weights, Killer Ants Basic and Killer Ants Bold. Killer Ants was created in a unique way. While working, Dever discovered a massive ant invasion in the garbage pail. After a quick application of ant killer, he decided to take some sample printouts and squash the dead ants with the prints. Dever scanned the prints with the dead ants and Killer Ants was born. According to the designer, "all of the specks you see were once ants. It's a killer font!"

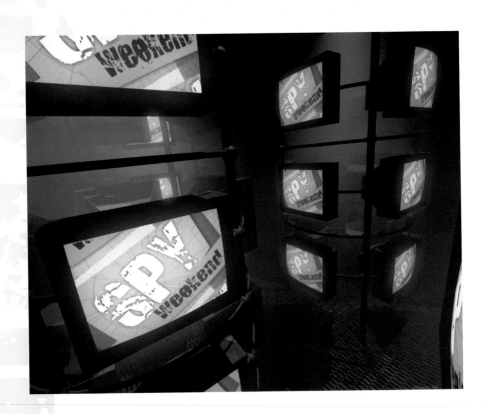

PURCHASE ONLINE AT: **http://www.cool-fonts.com**

Graphic Design ◁
Todd Dever

Purpose
**Broadcast
Animation**

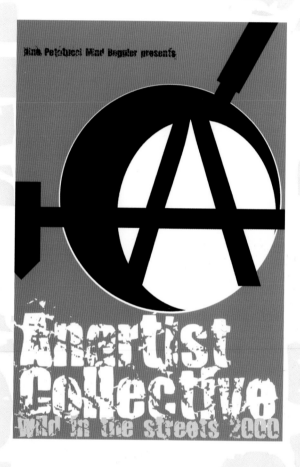

Graphic Design ▷
Todd Dever

Purpose
Postcard

KO Dirty

Font Name
KO Dirty

Style
Distressed

Alpha Page
237

immediately, among them Scritti Politti, who founded

"Smokescreen" around that

single

"Smokescree

made their **first** single "Smokescreen" around that

time. Other bands followed immediately, among them Scritti Politti, who founded

their own label, St. Pancras Records, carefully listing on the album

Typefaces: KO Dirty by Denis Dulude
design: 2R / 2Rebels 2000

photo
from Daily album

PURCHASE ONLINE AT: **http://www.2rebels.com**

Font Designer, Denis Dulude
Canada

Denis Dulude created KO Dirty in 1997 while searching for a cut-out scratchy font that was not available. KO Dirty was named after his design studio "KO Création." For highest legibility, this distressed sans serif font is best set at smaller sizes from 12 point to 36 point. It does look and print very well. but was mainly designed for screen display. The following are some of the special hidden characters included in this font: E-mail Symbol (option-W), Up Arrow (option-D), Right Arrow (option-J), Right Arrow (option-L), Down Arrow (option-X), Left Arrow (option-V) an Empty Square (option-Z) and Creation Year (option-shift P).

Graphic Design ◁
2Rebels

Purpose
2Rebels Exhibition
Poster

Graphic Design ▷
2Rebels

Purpose
KO Dirty Banner

KO Dirty

M

Font Name
Malcom

Font Families
Malcom Regular
Malcom Italic
Malcom Medium
Malcom Medium Italic
Malcom Bold
Malcom Bold Italic

Style
Contemporary

Alpha Page
238

Malcom

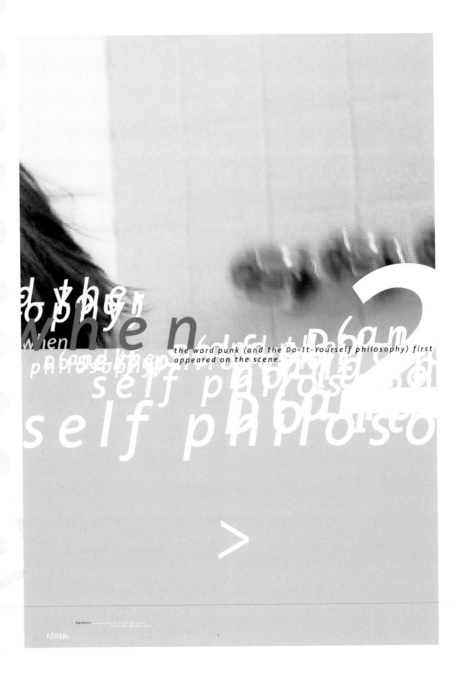

the word punk (and the Do-It-Yourself philosophy) first appeared on the scene.

PURCHASE ONLINE AT: **http://www.2rebels.com**

Font Designer, Éric de Berranger
France

Malcom is a straight line contemporary font created by Éric de Berranger. His search for straight line fonts led to the development of Malcom. This typefont is a good choice for modern style graphics, because it departs from the curves often found in classical fonts.

There are six weights that complete the perfect font family: Malcom Regular, Malcom Italic, Malcom Medium, Malcom Medium Italic, Malcom Bold and Malcom Bold Italic.

Graphic Design ◁
2Rebels

Purpose
Exhibition Poster

Graphic Design ▷
2Rebels

Purpose
Malcom Banner

Malcom

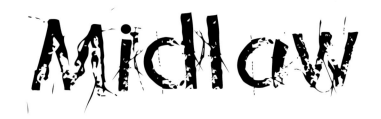

Font Name
Midlaw

Style
Distressed

Alpha Page
241

Font Designer, Marie-France Garon *Canada*

This distressed font Midlaw, designed by Marie-France Garon, was first created with the use of rubber stamps. On a large scale sheet of paper, Garon drew lines over the characters. The lines depict the instinctive writing once exercised by the French surrealist poets, from an automatic way of thinking or non-thinking. The letters were then scanned and imported into the Fontographer software where final adjustments were fine tuned.

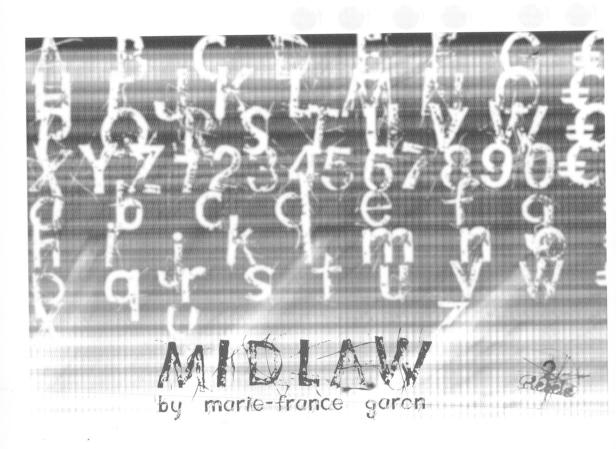

PURCHASE ONLINE AT: **http://www.2rebels.com**

Graphic Design ▷
2Rebels

Purpose
**2Rebels Exhibition
Poster**

AND WHAT YOU SEE IN THIS EXHIBITION IS WHERE WE ARE AT. IF YOU FEEL INSPIRED YOU SHOULD DO THE SAME.

Graphic Design ◁
2Rebels

Purpose
**Promotional
Mailer**

Wittgenstein

Don't ask for the meaning, ask for the use.

Typefaces: Midlaw by Marie-France Garon
design: PB/2Rebels, 2000

Midlaw

Mobilette

Font Name
Mobilette

Font Families
Mobilette Regular
Mobilette Italic
Mobilette Gas
Mobilette Oil
Mobilette Ain
Mobilette Pneu
Mobilette Script

Style
Contemporary

Alpha Page
241

Graphic Design
Tamye Riggs

Purpose
Ad in Eye No. 37, Vol. 10

typographic personalit

PART II: STRENGTH
Typefaces, much like the people who use
them, have distinctive personality traits.
What makes a typeface strong?
Large x-heights, prominent descenders,
boldly chiseled serifs, finely hewn finials.
fonts with these characteristics demand
attention, compelling us to read on.
Actually, the true test of typographic
strength lies in selecting the right face to
convey your ideas — it's all in your hands.

GARAGEFONTS HAS OVER 500 STRONG FACES.
VIEW AND ORDER SECURELY ONLINE.
GET YOUR FREE CATALOG TODAY.

GARAGEFONTS
garagefonts.com * 1.301.879.6955
14605 STURTEVANT RD, SILVER SPRING, MD 20905 USA

{nice fonts}

Font Designer, Thomas Schnäbele *Germany*

Mobilette is a text-usable display family. Beginning with
geometric shapes, designer Thomas Schnäbele worked
the letterforms into something "scriptoid," as he calls it. The
characters get more and more freedom from their geometrical
roots without denying them. In car design, there have been
many typefaces that show a mixture of constructive and script
lettershapes. Hence, the name Mobilette: a typeface that can be
considered contemporary while cruising along like a strange
old vehicle. Font weights include Mobilette Regular and Italic
plus Mobilette Gas, Oil, Air, Pneu and Script.

Graphic Design
**Thomas
Schnäbele**

Purpose
**Typeface
Promotional
Postcard**

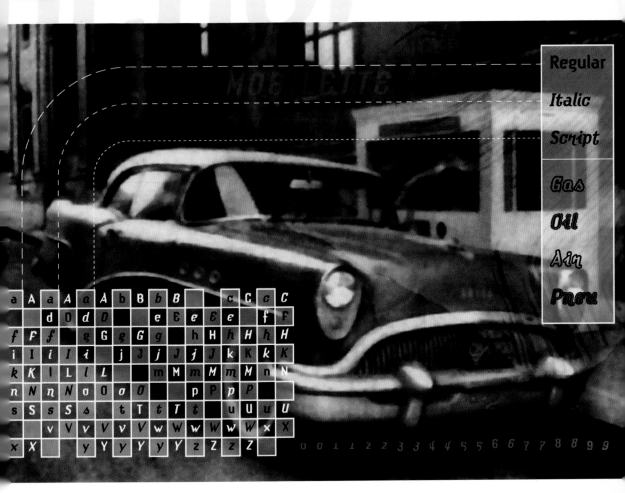

Mobilette

M

Font Name
Monako

Font Families
Monako Serif
Monako Sans

Style
Contemporary

Alpha Page
245

Monako

PURCHASE ONLINE AT: http://www.typeface2face.com
http://www.fontshop.de

Font Designer, Alexander Branczyk *Germany*

Alexander Branczyk developed Monako Sans and Monako Serif for use in a typography book he co-edited and designed, titled, Emotional Digital: Sourcebook for Contemporary Typographics. In search of a text typefont that was not ordinary, he based the font design on the brilliant Macintosh "Systemfont" Monaco. The original typeface, Monaco, had only one weight and because it is monospaced, it was not good to use as a typeface for long copy. Branczyk developed several versions and weights for Monako Sans and Monako Serif that would be readable. In addition, he added some extra medieval ziffers so the font would not be too ordinary.

Graphic Design ◁
Alexander Branczyk

Purpose
Poster

Graphic Design ▷
Alexander Branczyk

Purpose
Poster

Monako

New Clear Era

Font Name
New Clear Era

Font Families
New Clear Era
Regular
New Clear Era
Display One
New Clear Era
Display Two
NEW CLEAR
ERA DISPLAY
CAPS

Style
Contemporary

Alpha Page
246

PURCHASE ONLINE AT: **http://www.fontboy.com**

Font Designer, Bob Aufuldish

United States

New Clear Era is part of a large ongoing project that investigates classicism and legibility. The regular version is the base font. Numerous permutations will be performed on this underlying skeleton. The ideas of an extended type family are investigated while trying to understand what makes a contemporary serif typeface, legible. The type is not "extreme" in the usual sense of the word, but as text, is extremely easy to read.

Graphic Design ▷
Bob Aufuldish

Purpose
Book Cover

Graphic Design ◁
Bob Aufuldish

Purpose
Announcement

New Clear Era

New Paroxysm

Font Name
New Paroxysm

Font Families
New Paroxysm 1.0
New Paroxysm 1.1
New Paroxysm 2.0
New Paroxysm 2.1

Style
Techno

Alpha Page
248

Font Designer, Matius Gerardo Grieck *England, UK*

In its generic definition, paroxysm is a sudden fit of rage; a sharp explosion of anger. In an essay by J. Baudrillard called 'Le paroxyste indifférent' (Indifferent paroxysm), a contradiction in terms, a contemporary socio-philosophical framework is established, reflecting the effects of the perpetual loss of references and meaning, that generated our current infrastructure, where all extremes have been alienated to merge into singularity, making any form of resistance or confrontation obsolete.

PURCHASE ONLINE AT: **http://www.plusism.com**

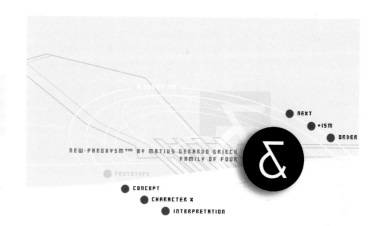

21.C purification
ΠEW·PAROXYSM
transfiguration

Graphic Design ▽
**Matius Gerardo
Grieck**

Purpose
**Digital Font
Catalogue
Presentation**

Graphic Design △
**Matius Gerardo
Grieck**

Purpose
**Digital Font
Catalogue
Presentation**

Πew Paroxysm

N

Newt

Font Name
Newt

Font Families
Newt Regular
Newt Italic
Newt Bold
Newt Bold Italic
Newt Mono Regular
Newt Mono Corroded Light
Newt Mono Corroded Heavy

Style
Contemporary

Alpha Page
250

Font Designer, Nicholas Carvan *Australia*

Newt was inspired by designer Nicholas Carvan's affection for distressed typewriter fonts. Carvan decided to design a new font and distress it as though it had been created in the 1800s. He updated the family, creating clean proportional text fonts to complement the original typewriter designs. Newt's big appeal is that it appears both retro and modern, in a brutal but harmonious alliance. The font families include the usual italics and bolds, but also features Newt Mono Regular, Mono Corroded Light and Mono Corroded Heavy.

Graphic Design
Tamye Riggs

Purpose
Typeface
Promotional Insert

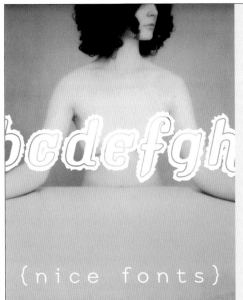
Graphic Design △
Tamye Riggs

Purpose
**Ad—Emigre No. 54 and
Eye No. 36, Vol. 9**

Newt

Font Name
Not Caslon

Style
**Contemporary
NeoClassic
Ornamental**

Alpha Page
252

Font Designer, Mark Andresen *United States*

Mark Andresen, the designer of NotCaslon, created this typeface for experimental posters for a punk music club called 688 in Atlanta, Georgia. This typeface remained unfinished until 1995 when Emigre showed an interest in it as a digital font. It was treated as a found artifact with an eye for its irregular details. The main influence for NotCaslon is the city of New Orleans itself with its 18th and 19th century French Quarter balconies, old cemetery crosses and Voudou veve designs.

The peculiar swashes and inconsistent italic letterforms are all pieces of Caslon Swash Italic broken press type, rearranged and spontaneously formed. "It was meant as a joke, really, but I became serious about finishing it as I started to enjoy the odd gracefulness of it." says Andresen. "It reels like drunken sailors on shore leave—the Black Sheep of the Caslon Family." This font has been exhibited at The Cooper-Hewitt Contemporary Museum's "Mixed Messages" retrospective graphic design show, and has been noticed on CD covers from Madonna to Lou Reed.

PURCHASE ONLINE AT: **http://www.emigre.com**

Not Caslon

NOT CASLON WAS DESIGNED BY MARK ANDRESEN

CIRCA 1995 65 DOLLARS

THE WILLIAM CASLON LINEAGE

NOT CASLON (1) NOT CASLON (2) NOT CASLON (1) NOT CASLON (2) NOT CASLON (1) NOT CASLON (2)

Graphic Design ▷
Rudy VanderLans

Purpose
**Promotional
Poster Release
of Not Caslon**

Graphic Design ◁
Mark Andresen

Purpose
Promotion

1 2 3 4 5 6 7 8 9 0

DIGITAL FONT CHARACTER SET

117

NOT CASLON

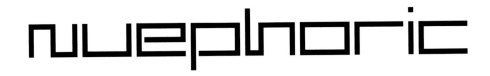

Font Name
Nuephoric

Font Families
nuephoric
regular
nuephoric
regular
italic
nuephoric
thin
nuephoric
thin italic
nuephoric
Heavy
nuephoric
Heavy italic

Style
**Contemporary
Techno**

Alpha Page
253

Font Designers, Lee Basford and James Glover *England, UK*

Nuephoric was designed by Lee Basford & James Glover at Fluid. Fluid fuses a computer game's world graphics font with experimental architect type from the 30s to form a unique angular typeface. This futuristic straight edged, chisled face contains six weights, Nuephoric Thin, Nuephoric Thin Italic, Nuephoric Regular, Nuephoric Regular Italic, Nuephoric Heavy and Nuephoric Heavy Italic.

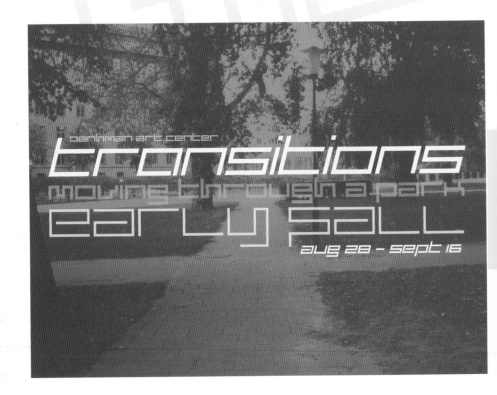

PURCHASE ONLINE AT: **http://www.fountain.com**

Graphic Design ▷
Peter Bruhn

Purpose
Typeface
Promotion

Graphic Design ◁
Peter Bruhn

Purpose
Typeface
Promotion

nuephoric

Oxtail

Font Name
Oxtail

Font Families
Oxtail Medium
Oxtail Medium Italic
Oxtail Bold
Oxtail Bold Italic
Oxtail Black
Oxtail Black Italic

Style
Experimental

Alpha Page
255

Font Designer, Stefan Hattenbach *Sweden*

Oxtail, designed by Stefan Hattenbach, has the robust, classic styling of a Clarendon; however, its hooked strokes and other idiosyncrasies give it the feel of a script, even in the Roman fonts. This distinctive font comes in three substantial weights with corresponding italics: Oxtail Medium, Oxtail Medium Italic, Oxtail Bold, Oxtail Bold Italic, Oxtail Black and Oxtail Black Italic.

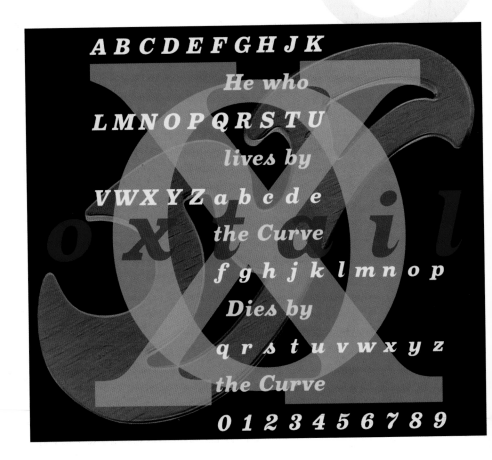

ABCDEFGHJK
He who
LMNOPQRSTU
lives by
VWXYZabcde
the Curve
fghjklmnop
Dies by
qrstuvwxyz
the Curve
0123456789

PURCHASE ONLINE AT: **http://www.psyops.com**

Graphic Design ◁
Rodrigo Cavazos

Purpose
**Cover Artwork for
Oxtail Specimen
Booklet**

Graphic Design ▷
Rodrigo Cavazos

Purpose
**Promotional
Mini-poster for
Oxtail Typeface**

Oxtail

Percolator

Font Name
Percolator

Font Families
percolator Bold
Percolator
Expert
Percolator Text
percolator
Regular

Style
**Contemporary
Techno**

Alpha Page
258

Font Designer, Adam Roe *United States*

Inspired by a futuristic film, Percolator emulates the familiar shapes of a classic text font to appear legible when used as text, yet as a headline font appears both modern and gothic. This "classic-future" mix is perhaps the most accurate representation of typefaces to come. Since most representations of the future ignore the past entirely, nothing in the future will be old. When in reality, it will be a blend of both. There may be flying cars, as well as the old 3-speed bikes, too but Percolator endeavors to represent both typographically.

Graphic Design
Adam Roe

Purpose
Promotional Card

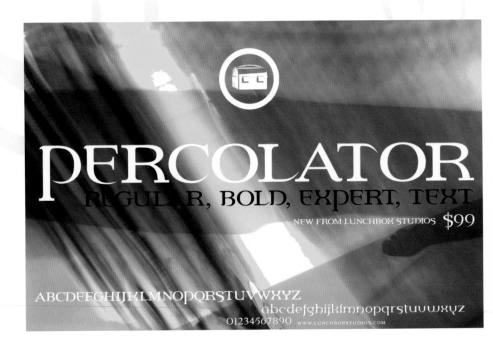

PURCHASE ONLINE AT: **http://www.lunchboxstudios.com**

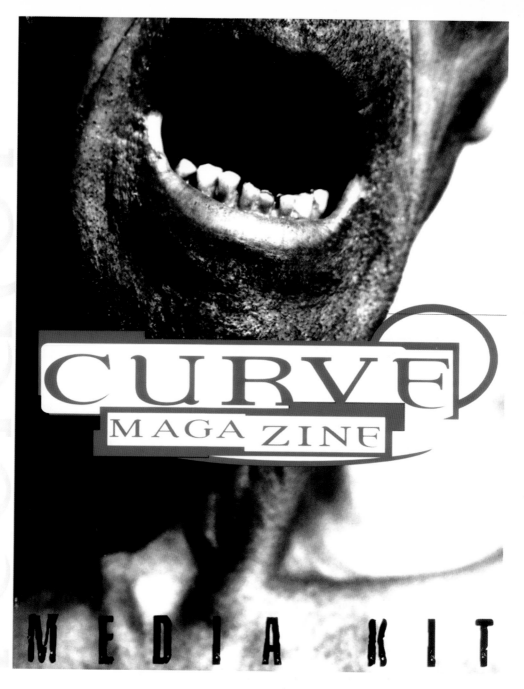

Graphic Design
Adam Roe

Purpose
Curve Magazine
Media Kit

Plankton-b

Font Name
Plankton-b

Style
Experimental
Organic

Alpha Page
260

Font Designer, Don Barnett
United States

Plankton-b is a highly experimental font designed by Don Barnett. He abandons typical forms of the alphabet, and recreates the letter image through new forms. It proved to be a nearly impossible task. The shapes are influenced by microscopic and calligraphic forms. One feature of the typeface was to balance elements of chaos with elements of perfection; for example, perfect circles intersected with twisted or calligraphic shapes. Plankton-b endeavors to build a typeface which combines the organic with the inorganic.

Graphic Design ◁
Don Barnett

Purpose
Typeface
Promotion

Graphic Design ▷
Don Barnett

Purpose
Typeface
Promotion

PURCHASE ONLINE AT: **http://www.donbarnett.com**

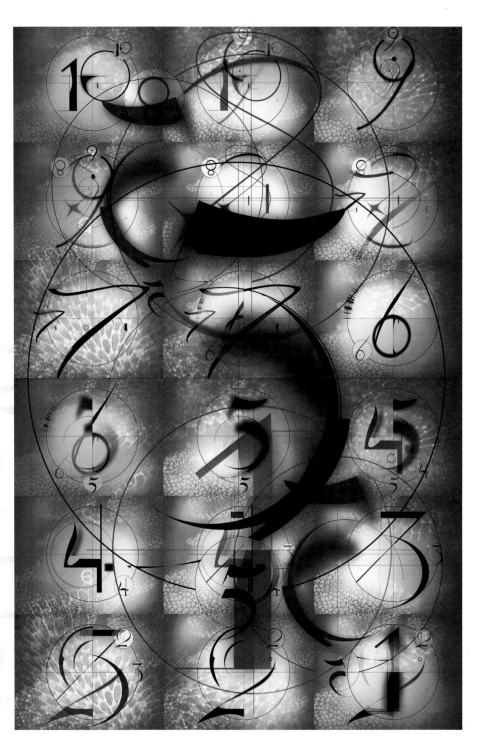

plankton

P

Font Name
Poor Richard

Style
NeoClassic

Alpha Page
260

Poor Richard

Font Designer, Phil's Fonts Studio *United States*

Poor Richard is a display and text design font with an old-fashioned feeling. Its playful features add a touch of whimsy while maintaining an attitude of strength. Poor Richard's curved bowls bend around, stopping short of connecting. The elegant neoclassic typefont portrays a solid foundation with delicate negative space inside the eyes to soften the bold construction of the letterforms.

PURCHASE ONLINE AT: **http://www.philsfonts.com**

TEMPUS FUGIT

TIME HEALS ALL WOUNDS

TIME AND TIDE WAIT FOR NO MAN

TIME IS ON MY SIDE

TIME FOR ME TO FLY

WHAT TIME IS IT

TIME KILLS LOVE

TAKE YOUR TIME

TIME AFTER TIME

TIME IN A BOTTLE

TIME THE AVENGER

TIME ENOUGH FOR LOVE

IF YOU'VE GOT THE TIME

TIME-SHARE IN THE HAMPTONS

A TIME FOR US

Graphic Design ◁
Tamye Riggs

Purpose
**Typeface
Promotional
Postcard**

Graphic Design ▷
Tamye Riggs

Purpose
**Typeface
Promotional
Poster**

Poor Richard

Porno

Font Name
Porno

Font Families
Porno Hard
Porno Soft
Porno Kinky
Porno Kinky
SM

Style
Experimental

Alpha Page
261

Graphic Design
Pieter van Rosmalen

Purpose
Typeface Promotional Poster

PURCHASE ONLINE AT: **http://www.garagefonts.com**

Font Designer, Pieter van Rosmalen *The Netherlands*

Pieter van Rosmalen chose the name Porno while designing this wicked type family. Porno comes in four appropriate weights, Porno Hard, Porno Soft, Porno Kinky and Porno Kinky SM. "The original style is Soft," Pieter says. "It's a very dirty face, so the name had to be dirty, as well. When designing the Hard version, I named the font Porno Hard. Soft, Hard—what comes next? Well, Kinky and Kinky SM. The Kinky SM letterforms are hurting each other with their large spikes. They like that…"

Graphic Design
Tamye Riggs

Purpose
Typeface
Promotional
Postcard

Post Mono

Font Designer, Joshua Distler *United States*

Font Name
PostMono

Font Families
Post Mono
Normal
Post Mono
Medium
Post Mono
Light
Post Mono
Bold
Post Mono
Black

Style
Techno

Alpha Page
263

Post Mono is a monospaced text and display face which is drawn using straight lines. It works well for situations where high readability is required at an excessively small point size. A full accent set accompanies the font. Post Mono weights include Post Mono Normal, Post Mono Medium, Post Mono Light, Post Mono Bold and Post Mono Black.

VERSION-A
071000[[[#]]]
MODULATED
}

image 001 PHASEaxis_%

mono_audio_[outpu

PURCHASE ONLINE AT: **http://www.shiftype.com**

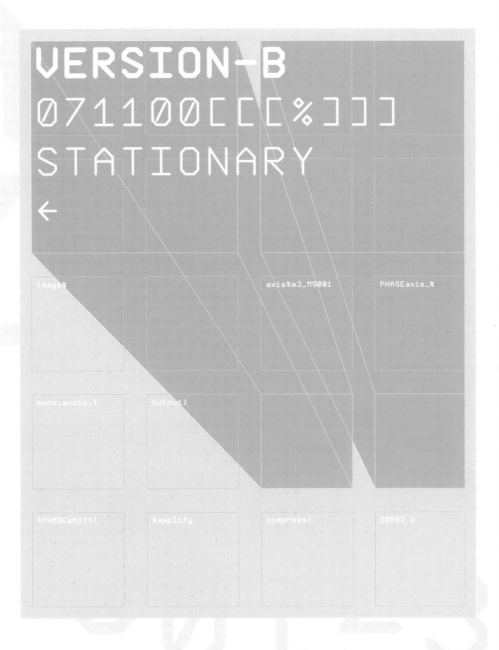

VERSION-B
071100[[[%]]]
STATIONARY
←

Graphic Design ◁
Joshua Distler

Purpose
Poster Concepts

Graphic Design △
Joshua Distler

Purpose
Poster Concepts

Post Mono

Punctual

Font Name
Punctual

Font Families
Punctual Four
Punctual Four
Inline
Punctual Four
Interior
Punctual Four
universal

Style
Contemporary

Alpha Page
264

Font Designer, Bob Aufuldish *United States*

Punctual was designed by connecting a grid of dots. The name, Punctual, is derived from the German word for point, *punkt*. The lines that connect the dots are the same thickness as the points. An expanded version, with variation in the line weights connecting the points is available at www.fontboy.com. The font is spaced geometrically. The width of each character is determined by its geometry, and nearly all the characters have the same width. The "Universal" versions have no descenders—characters that would ordinarily have them are redesigned. In addition, lower case characters without ascenders are designed to reach the cap height.

The family consists of regular, inline and interior variations with "Universal" versions of each. The "interior" version is a font made of the negative spaces in "inline," with the same spacing. If the same text is set in both versions and overlapped, both fonts align perfectly. This is useful for creating a multicolored inline.

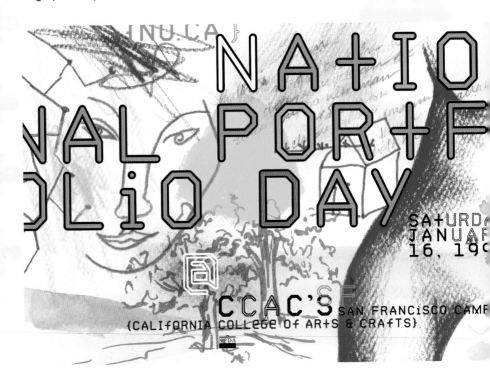

PURCHASE ONLINE AT: **http://www.fontboy.com**

Graphic Design ◁
Bob Aufuldish

Illustrator
Kathy Warinner

Purpose
Postcard

Graphic Design ▷
Bob Aufuldish

Illustrator
Kathy Warinner

Purpose
Poster

Punctual

Font Name
Raven

Font Families
Raven
Raven EverMore

Style
**Contemporary
Gothic
Decorative**

Alpha Page
266

Font Designer, Holly Goldsmith *United States*

A pointed, piercing design, moderately gothic in nature, Raven is the perfect typefont to gain "a little bit of an edge," reveals Holly Goldsmith, designer. The font has a few extras that will enhance the slightly dark appearance of the typeface, which include its four flying ravens. This typefont has two weights: Raven, and Raven Evermore for a stronger impact. Legible in small sizes, it lends itself beautifully for display.

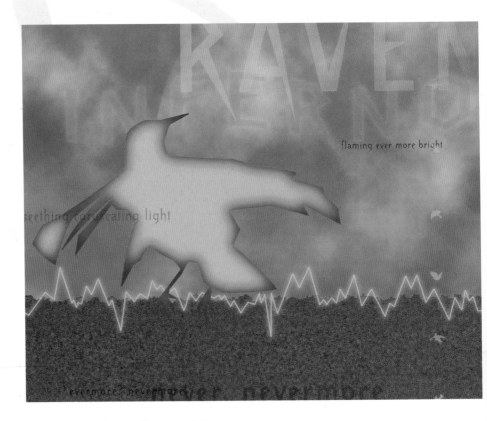

PURCHASE ONLINE AT: **http://www.bitstream.com
http://www.FORdesigners.com**

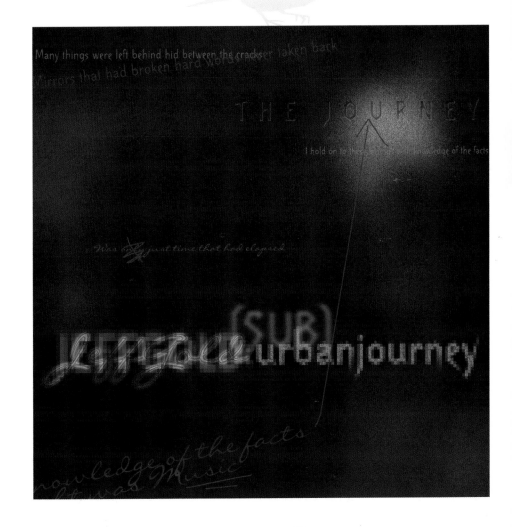

Graphic Design ◁
Holly Goldsmith

Purpose
**Font Release
Poster**

Graphic Design ▷
Holly Goldsmith

Purpose
CD Cover Concept

REQUIEM

Font Name
Requiem

Font Families
REQUIEM
DIES IRAE 1.0

REQUIEM
DIES IRAE 1.1

REQUIEM
SIMPLEX 2.0

REQUIEM
SIMPLEX 2.1

Style
NeoClassic

Alpha Page
267

Font Designer, Matius Gerardo Grieck *England, UK*

Requiem Dies Irae is constructed by applying a technical frame to each character, in which geometrical forms help to determine exact proportions to all angles, strokes and curves. Although the technical frames are usually discarded in the end, individual construction elements are incorporated as part of the characters.

The concept originated in questioning the role of the serif, which originated, while finishing off the stroke of hand written letters, which does not apply to computer generated typefaces. When creating Requiem Simplex in which traditional serifs are left out and all curves and strokes are altered, only the most eccentric elements, which then became 'serifs' of their own, remain.

Graphic Design
Matius Gerardo Grieck

Purpose
Digital Font Catalogue Presentation

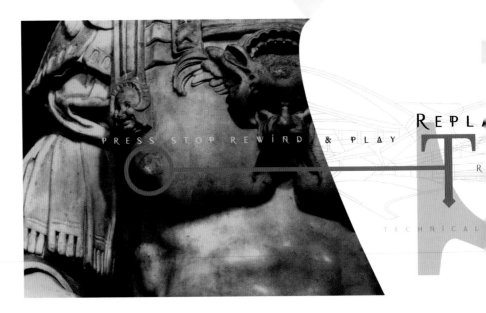

REQUIEM [DIES IRAE]™ BY MATIUS GERARDO GRIECK
FAMILY OF FOUR

R 90037 TM

NEXT

•ISM

ORDER

PROTOTYPE

CONCEPT

CHARACTER X

INTERPRETATION

SENSATIC

CONSCIUOSN

SEEMING TO

TION OF BOD

(EVENT, PERS

Requiem [Dies Irae]

Requiem [Simpi

Graphic Design
**Matius Gerardo
Grieck**

Purpose
**Digital Font
Catalogue
Presentation**

UR LIFE

MATERIALIZED ELF

ESTICATED IMMORTALITY

REQUIEM

Sabotage

Font Name
Sabotage

Style
Contemporary
Distressed
Experimental
Grunge
Organic
Techno

Alpha Page
269

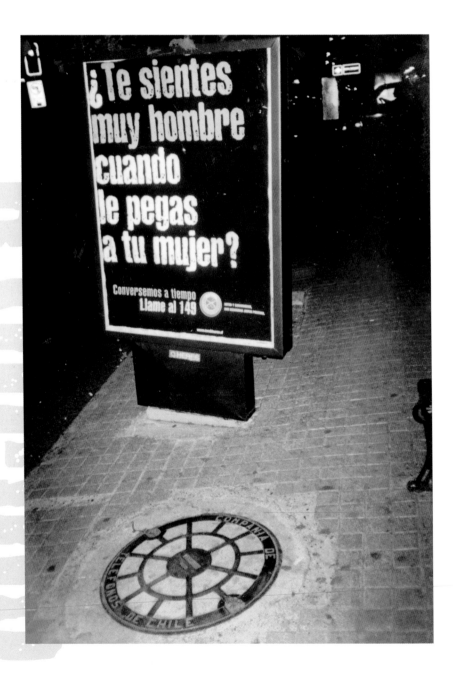

PURCHASE ONLINE AT: **http://www.lunchboxstudios.com**

Font Designer, Adam Roe

United States

Designed originally for publication, Sabotage was created for headline purposes to work as a low memory solution to replace manually treating each typeface. Sabotage's original letter forms were repeatedly photocopied then re-scanned to appear genuinely worn out and distressed. This produced random effects which were difficult to achieve through illustration programs alone. Letterforms were then cleaned and optimized to lessen print time. The goal was to achieve a distressed typeface that remained approachable and friendly.

Graphic Design ◁
Adam Roe

Purpose
Bus Station Sign

Graphic Design ▷
Adam Roe

Purpose
**Sabotage
Promotional Card**

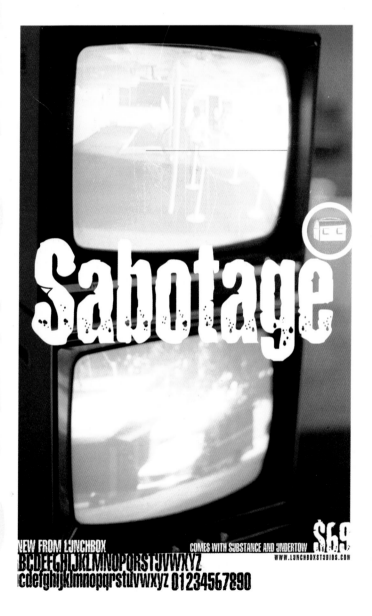

SCi-Fi

Font Name
Sci-Fi Classic

Style
Techno

Alpha Page
269

Graphic Design ▽
Swifty

Purpose
**Record LP/CD
Cover**

Graphic Design ▷
Swifty

Purpose
**Record LP/CD
Cover**

Font Designer, Swifty *England, UK*

Sci-Fi Classic's cool modern letterforms were influenced by
the futuristic science fiction films of the 1980s. The curved
initial set of characters lends itself best as a display font. The
rounded square shaped letterforms are kerned closely
together for a solid appearance with a subtle alien attitude.

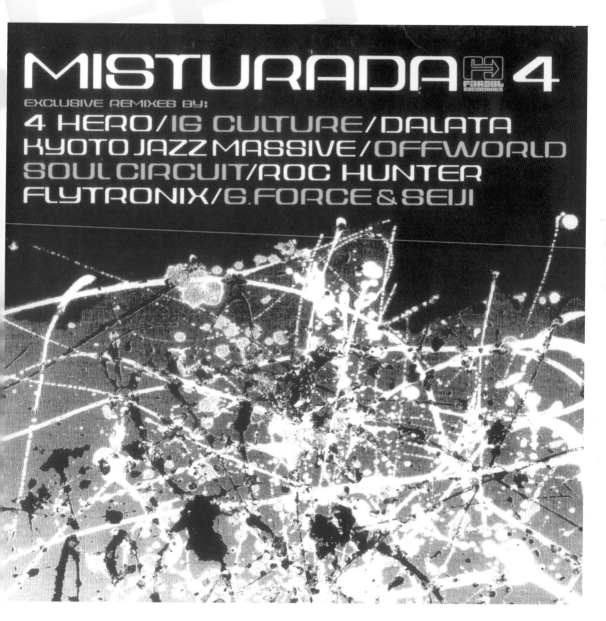

ITC Talking Drum

Font Name
ITC Talking Drum

Font Families
Talking Drum
TALKING
DRUM CAPS

Style
Contemporary

Alpha Page
270

Font Designer, Timothy Donaldson *England, UK*

British designer Timothy Donaldson has had some fun in designing ITC Talking Drum™, a bold, spiky face with four versions of every letter. This is a unique new sans serif, in which the ascending and descending elements of the cap and lowercase letterforms have been carefully thought out to provide an interesting texture when used in word sets. Thick, diagonal stroke-ends give the lowercase a scooped-out look, and the capital letters, especially the variants in the ITC Talking Drum™ Caps font, use a heavy diamond shape to suggest a playful contemporary version of textura type. ITC Talking Drum™ is dramatic, witty, and surprisingly versatile for such a highly stylized face. Donaldson has included several ornaments and patterns to complete the set.

PURCHASE ONLINE AT: **http://www.itcfonts.com**

Drum

3

Graphic Design ◁
**Timothy
Donaldson**

Purpose
**Book Jacket
Design**

Graphic Design ▷
**Timothy
Donaldson**

Purpose
Festival Imagery

ITC Talking Drum

T

Technique

Font Name
Technique

Font Families
Technique Light
Technique Regular

Style
**Contemporary
Distressed
Techno**

Alpha Page
271

Font Designer, Adam Roe *United States*

Technique was a pause in the search for the perfect headline font. This font merges serifs and sans serifs into the same form and uses a 3 to 1 height to width ratio found in many headline fonts. Technique utilizes the serifs and counter serifs within the letterforms stem to create this balance. The odd mix of serif and sans serif gives it a common yet unfamiliar characteristic, lending it to both modern and classical use.

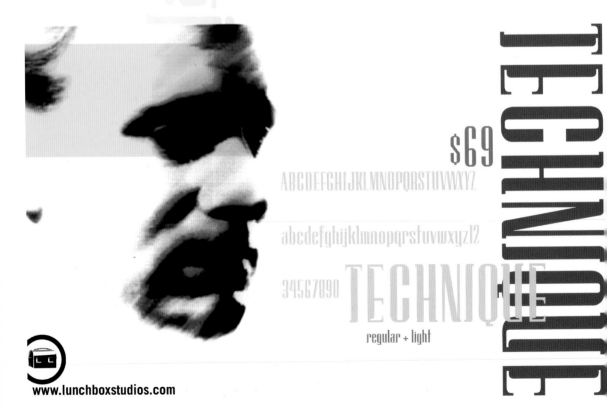

$69

ABCDEFGHIJKLMNOPQRSTUVWXYZ

abcdefghijklmnopqrstuvwxyz12

34567890 TECHNIQUE

regular + light

TECHNIQUE

www.lunchboxstudios.com

http://www.t26.com
PURCHASE ONLINE AT: http://www.lunchboxstudios.com

Graphic Design ▷
Adam Roe

Purpose
Technique
Promotional Card

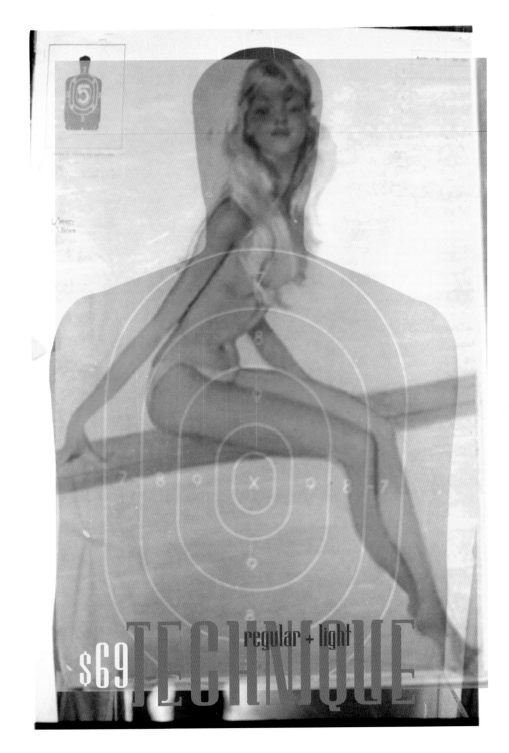

Graphic Design ◁
Adam Roe

Purpose
Technique
Promotional Card

T

Font Name
Thin Man

Font Families
THIN MAN
REGULAR

THIN MAN
DRUNK

Style
Experimental

Alpha Page
271

THIN MAN

The British band The Desperate Bicycles, the group most often cited as the original rock DIYers.

Font Designer, Denis Dulude *Canada*

Thin Man was created in 1996 by lean Denis Dulude of 2Rebels. If there could be a self portrait of a typeface, this would be the one! He was searching for a very thin font that was not too clean and not too dirty. Dulude developed the experimental not so clean characteristic by cutting out small parts of characters. The font was designed for use as all caps with no lower case characters. Thin Man is best set with tight leading, for example: 48/30. Thin Man has two weights, Thin Man Regular and Thin Man Drunk.

Graphic Design ◁
2Rebels

Purpose
**2Rebels Exhibition
Poster**

Graphic Design ▷
2Rebels

Purpose
ThinMan Banner

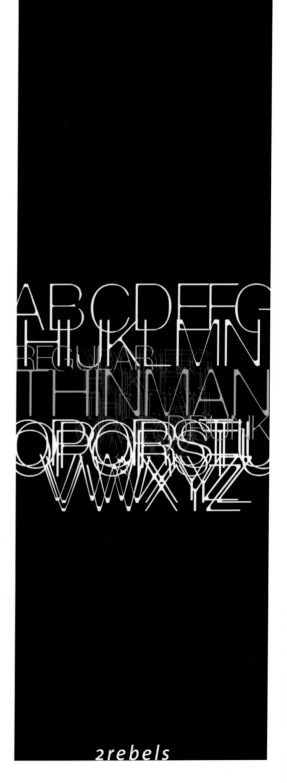

THIN MAN

U

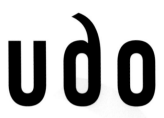

udo

Font Name
Udo

Font Families
udo
udo leaned
udo wide
udo wide leaned

Style
Contemporary

Alpha Page
272

Graphic Design
Peter Bruhn

Purpose
Typeface Promotion

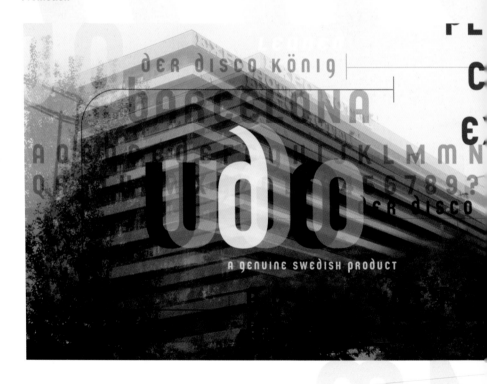

PURCHASE ONLINE AT: **http://www.fountain.com**

Font Designer, Peter Bruhn *Sweden*

A clean font with Bauhaus references, Udo is a contemporary font designed by Peter Bruhn, that has many applications in various point sizes. The real name, is "Udo—der disco koenig," German for "Udo—the disco king." Especially useful as a display font, Udo includes four weights, Udo, Udo Lean, Udo Wide and Udo Wide Lean.

Graphic Design
Peter Bruhn

Purpose
Typeface
Promotion

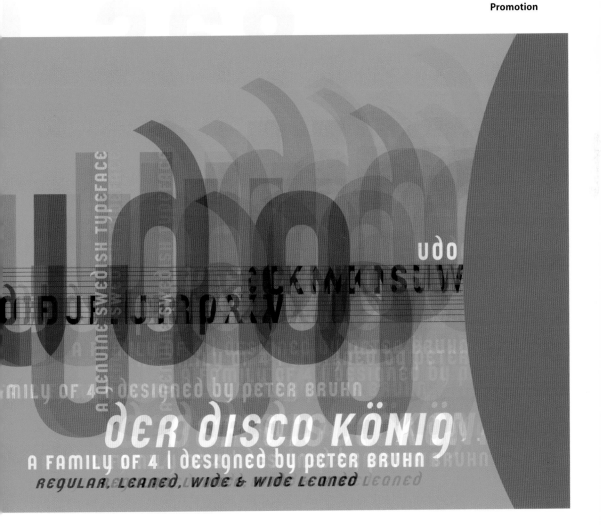

udo

Unisphere

Font Name
Unisphere

Font Families
Unisphere Light
*Unisphere Light
Italic*
Unisphere
Regular
Unisphere Italic
**Unisphere
Bold**
***Unisphere
Bold Italic***

Style
Contemporary

Alpha Page
274

Font Designer, Rodney Shelden Fehsenfeld *United States*

According to designer Rodney Shelden Fehsenfeld, the motivation for Unisphere was simple. He wanted to design a typeface he could use anywhere or any way. It began five years ago, when he lost touch with a similar, but not-quite-right, font project, Portential (circa 1995), based on the gothics. After seeing what went wrong with Portential, he drafted a few more experiments. Unisphere was left unused-at the time, in his scope-for being too normal. Unisphere is clean and proper, but done in Fehsenfeld's own special way. Perfect for setting both text and heads, Unisphere can be used in any medium or project. Its use is not limited to a specific style, tone or visual voice.

Graphic Design
**Rodney Shelden
Fehsenfeld**

Purpose
**Typeface
Promotional Flyer**

NOTMUCHFUNBUTSINCERE
chargedandwaiting
UNISPHERE
abcdefghijklmnopqrstuvwxyz
UNISPHERE
UNISPHERE
ABCDEFGHIJKLMNOPQRSTUVWXYZ
in three weights

PURCHASE ONLINE AT: **http://www.garagefonts.com**

Graphic Design
**Rodney Shelden
Fehsenfeld**

Purpose
**Typeface
Promotional Flyer**

UNISPHERE

in three weights

in three weights

in three weights

three weights

three weights

in three weights

Unisphere

Whiplash

Font Name
Whiplash

Font Families
Whiplash Regular
Whiplash
Regular Mono
Whiplash
Lineola

Style
Contemporary

Alpha Page
277

Graphic Design
Bob Aufuldish

Purpose
**Beyond the
Margins of the
Page Project**

the letter, the word, the sentence, the page, is treated as a purely visual gesta lt independent o f, though still mirroring, the significance of t he word, sentenc e, paragraph, pa ge.

PURCHASE ONLINE AT: **http://www.fontboy.com**

Font Designer, Bob Aufuldish *United States*

Whiplash demonstrates the meeting of an engineer's template and a pressure-sensitive input device. The underlying structure is rational; the form resting on that structure is processed-based. The "mono" and "lineola" variations are monospaced, further suggesting the contrast between the rational and process-based form which, not incidentally, gives them the ability to be interchanged. Whiplash Lineola uses "interference" to subvert the rational grid structure formed by monospacing.

Graphic Design
Bob Aufuldish

Purpose
Beyond the Margins of the Page Project

Imagine the fisherman standing on the shore and casting a line into the ocean. Imagine the immensity of the Pacific and the inconsequential frame of a human being.

What an astonishing act; what an absurd image. To expect to catch something under these conditions is almost pathological. The pursuit of meaning is an even more astonishing act as we cast into a vastly greater ocean. It requires a type of faith.

Whiplash

W

Font Name
Wicked

Style
Contemporary

Alpha Page
278

Wicked

Font Designer, Phil's Fonts Studio
United States

Wicked is a display design typeface that evokes a classic, yet contemporary feel that also works well at smaller sizes. Wicked's exaggerated, sharply-cut serifs add bite, contrasting with the elegant curves of the letterforms. The elliptical bowls add a characteristic that is naughty, but nice—and just a little wicked.

Graphic Design ▽
Tamye Riggs

Purpose
Typeface
Promotional
Postcard

Graphic Design ▷
Tamye Riggs

Purpose
Typeface
Promotional
Poster

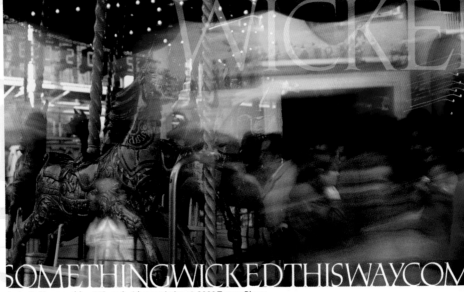

Lyrics to "Armageddon 18" used with permission. © 2000 Tamye Riggs

PURCHASE ONLINE AT: **http://www.philsfonts.com**

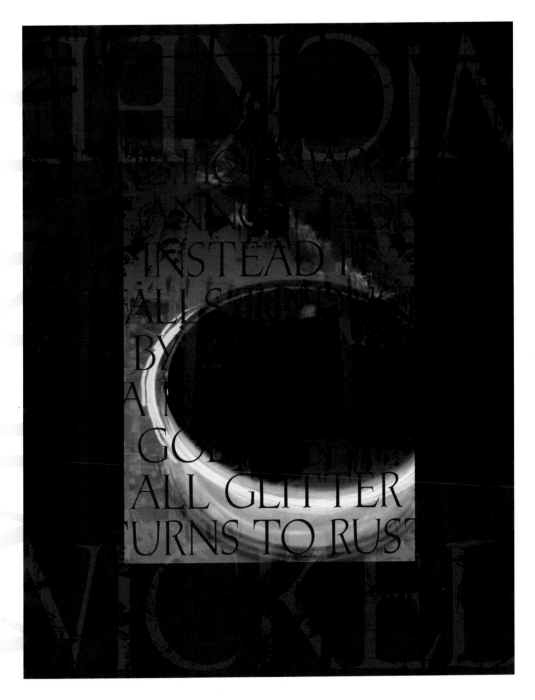

INSTEAD I
FALL SHUDDERING
BY
A
GO...
ALL GLITTER
TURNS TO RUST

Wicked

Font Name
LINOTYPE Zapfino

Font Families
Zapfino Nr. 1
Zapfino Nr. 2
Zapfino Nr. 3
Zapfino Nr. 4

Style
Hand Drawn
Ornamental

Alpha Page
278

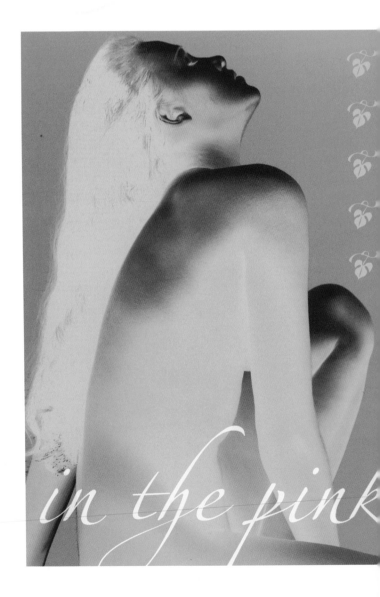

Zapfino

in the pink

Font Designer, Hermann Zapf *Germany*

The new Linotype Zapfino is artistically and technically a masterpiece from the master himself, Hermann Zapf, which combines traditional and modern typography. Linotype Zapfino is a complex font that can be used on the computer for creating calligraphic script layout designs with beautiful flourishes. Zapfino has four alphabets that can be interchanged and mixed. The basic alphabet can be mixed with any of the lower case character variants. In addition, a particular style can be created by exchanging individual characters in the ornamental swash upper case character sets. Additional alternative characters include a choice of ampersands and more than 100 ornamental decorative and informative fonts. The Type Directors Club of New York recently awarded Linotype Zapfino the prestigious TDC Type Design Award.

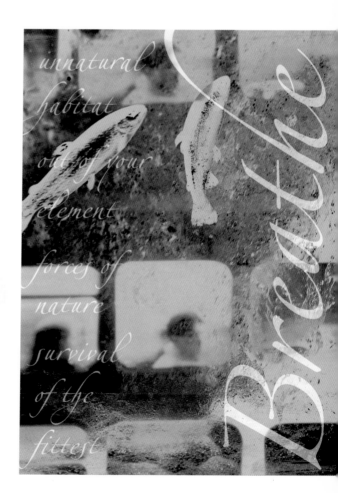

Graphic Design ◁
Tamye Riggs

Purpose
Font Promotion

Graphic Design ▷
Tamye Riggs

Purpose
Font Promotion

Zapfino

ALPHA SPECIMEN LISTING

ABCDEFGhiJ
KLMNOPQRS
TUVWXYZ
abcdefghij
klmnopqrs
tuvwxyz
1234567890
!@#$%^&*()

Air Mail P.18

Air Mail Regular

ABCDEFGHIJKLMN
OPQRSTUVWXYZ
abcdefghijklmnop
qrstuvwxyz
1234567890
!AT NO $%^&*()

Air Mail Postage

Air Mail P.18

Air Mail Regular

ABCDEFGHIJKLMN
OPQRSTUVWXYZ
abcdefghijklmnop
qrstuvwxyz
1234567890
!AT NO $%^&*()

Air Mail Postage

Alembic P.20

Alembic Regular One

ABCDEFGHIJ
KLMNOPQRS
TUVWXYZ
abcdefghijkl
mnopqrstuv
wxyz
1234567890
!@#$%^&*()

Alembic Regular Two

ABCDEFGHIJ
KLMNOPQRS
TUVWXYZ
abcdefghijkl
mnopqrstuv
wxyz
1234567890
!@#$%^&*()

Alembic P.20

Alembic Regular One

ABCDEFGHIJ
KLMNOPQRS
TUVWXYZ
abcdefghijkl
mnopqrstuv
wxyz
1234567890
!@#$%^&*()

Alembic Regular Two

ABCDEFGHIJ
KLMNOPQRS
TUVWXYZ
abcdefghijkl
mnopqrstuv
wxyz
1234567890
!@#$%^&*()

Alembic P.20

Alembic Regular Italic One

ABCDEFGHIJ
KLMNOPQRS
TUVWXYZ
abcdefghijkl
mnopqrstuv
wxyz
1234567890
!@#$%^&*()

Alembic Regular Italic Two

ABCDEFGHIJ
KLMNOPQRS
TUVWXYZ
abcdefghijkl
mnopqrstuv
wxyz
1234567890
!@#$%^&*()

Alembic P.20

Alembic Regular Italic One

ABCDEFGHIJ
KLMNOPQRS
TUVWXYZ
abcdefghijkl
mnopqrstuv
wxyz
1234567890
!@#$%^&*()

Alembic Regular Italic Two

ABCDEFGHIJ
KLMNOPQRS
TUVWXYZ
abcdefghijkl
mnopqrstuv
wxyz
1234567890
!@#$%^&*()

Alembic P.20

Alembic P.20

Alembic Bold One

ABCDEFGHIJ
KLMNOPQRS
TUVWXYZ
abcdefghijkl
mnopqrstuv
wxyz
1234567890
!@#$%^&*()

Alembic Bold One

ABCDEFGHIJ
KLMNOPQRS
TUVWXYZ
abcdefghijkl
mnopqrstuv
wxyz
1234567890
!@#$%^&*()

Alembic Bold Two

ABCDEFGHIJ
KLMNOPQRS
TUVWXYZ
abcdefghijkl
mnopqrstuv
wxyz
1234567890
!@#$%^&*()

Alembic Bold Two

ABCDEFGHIJ
KLMNOPQRS
TUVWXYZ
abcdefghijkl
mnopqrstuv
wxyz
1234567890
!@#$%^&*()

Alembic P.20

Alembic Bold Italic One

ABCDEFGHIJ
KLMNOPQRS
TUVWXYZ
abcdefghijkl
mnopqrstuv
wxyz
1234567890
!@#$%^&*()

Alembic Bold Italic Two

ABCDEFGHIJ
KLMNOPQRS
TUVWXYZ
abcdefghijkl
mnopqrstuv
wxyz
1234567890
!@#$%^&*()

Alembic P.20

Alembic Bold Italic One

ABCDEFGHIJ
KLMNOPQRS
TUVWXYZ
abcdefghijkl
mnopqrstuv
wxyz
1234567890
!@#$%^&*()

Alembic Bold Italic Two

ABCDEFGHIJ
KLMNOPQRS
TUVWXYZ
abcdefghijkl
mnopqrstuv
wxyz
1234567890
!@#$%^&*()

Alien Hidden P.22

Alien Hidden

Alien Grey

Alien Hidden P.22

Alien Hidden

Alien Grey

Anthropolymorphics 1.0

ABCDEFGHIJKLMN
OPQRSTUVWXYZ
abcdefghijklmn
opqrstuvwxyz
1234567890
!@#$%^&*()

Anthropolymorphics 1.1

ABCDEFGHIJKLMN
OPQRSTUVWXYZ
abcdefghijklmn
opqrstuvwxyz
1234567890
!@#$%^&*()

Anthropolymorphics P.24

Anthropolymorphics 1.0

ABCDEFGHIJKLMN
OPQRSTUVWXYZ
abcdefghijklmn
opqrstuvwxyz
1234567890
!@#$%^&*()

Anthropolymorphics 1.1

ABCDEFGHIJKLMN
OPQRSTUVWXYZ
abcdefghijklmn
opqrstuvwxyz
1234567890
!@#$%^&*()

Anthropolymorphics 2.0

ABCDEFGHIJKLMN
OPQRSTUVWXYZ
abcdefghijklmn
opqrstuvwxyz
1234567890
!@#$%^&*()

Anthropolymorphics 2.1

ABCDEFGHIJKLMN
OPQRSTUVWXYZ
abcdefghijklmn
opqrstuvwxyz
1234567890
!@#$%^&*()

Armature Light

ABCDEFGHIJKL
MNOPQRSTUV
WXYZ
abcdefghijklmn
opqrstuvwxyz
1234567890
!@#$%^&*()

Armature Regular

ABCDEFGHIJKL
MNOPQRSTUV
WXYZ
abcdefghijklmn
opqrstuvwxyz
1234567890
!@#$%^&*()

Armature P.26

Armature Light

ABCDEFGHIJKL
MNOPQRSTUV
WXYZ
abcdefghijklmn
opqrstuvwxyz
1234567890
!@#$%^&*()

Armature Regular

ABCDEFGHIJKL
MNOPQRSTUV
WXYZ
abcdefghijklmn
opqrstuvwxyz
1234567890
!@#$%^&*()

Armature Bold

ABCDEFGHIJKL
MNOPQRSTUV
WXYZ
abcdefghijklmn
opqrstuvwxyz
1234567890
!@#$%^&*()

Armature Extra Bold

ABCDEFGHIJK
LMNOPQRSTU
VWXYZ
abcdefghijklmn
opqrstuvwxyz
1234567890
!@#$%^&*()

Armature P.26

Armature Bold

ABCDEFGHIJKL
MNOPQRSTUV
WXYZ
abcdefghijklmn
opqrstuvwxyz
1234567890
!@#$%^&*()

Armature Extra Bold

ABCDEFGHIJK
LMNOPQRSTU
VWXYZ
abcdefghijklmn
opqrstuvwxyz
1234567890
!@#$%^&*()

Ars Magna Lucis 1.0

Ars Magna Lucis 1.1

Ars Magna Umbrae P.28

Ars Magna Umbrae 2.0

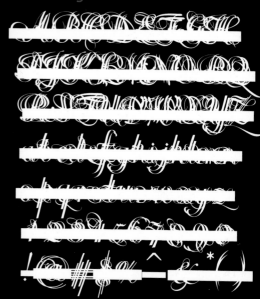

Ars Magna Umbrae 2.1

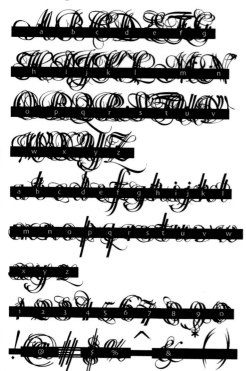

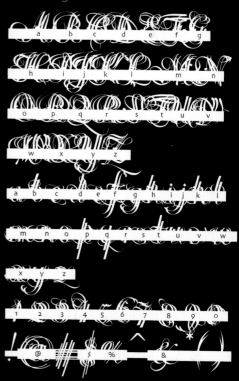

Article 10 Regular

ABCDEFGHI
JKLMNOPQ
RSTUVWXYZ

abcdefghijklmnopqr
stuvwxyz

1234567890

!@#$%^ & ()*

Article 10 Bold

ABCDEFGHI
JKLMNOPQ
RSTUVWXYZ

abcdefghijklmnopqr
stuvwxyz

1234567890

!@#$%^ & ()*

Article 10 Regular

ABCDEFGHI
JKLMNOPQ
RSTUVWXYZ

abcdefghijklmnopqr
stuvwxyz

1234567890

!@#$%^ & ()*

Article 10 Bold

ABCDEFGHI
JKLMNOPQ
RSTUVWXYZ

abcdefghijklmnopqr
stuvwxyz

1234567890

!@#$%^ & ()*

Bad Eggs Bold P.32

Bad Eggs Bold

ABCDEFGHIJKL
MNOPQRSTUV
WXYZ
abcdefghijkl
mnopqrstuv
wxyz
1234567890
!@#$%^+*()

Bauer Text Initials P.34

Bauer Text Initials

ABCDEFGHIJK
LMNOPQRST
UVWXYZ
ABCDEFGHIJKLM
NOPQRSTUVW
XYZ
1234567890
!@#$%^& *()

Bad Eggs Bold P.32

Bad Eggs Bold

ABCDEFGHIJKL
MNOPQRSTUV
WXYZ
abcdefghijkl
mnopqrstuv
wxyz
1234567890
!@#$%^+*()

Bauer Text Initials P.34

Bauer Text Initials

ABCDEFGHIJK
LMNOPQRST
UVWXYZ
ABCDEFGHIJKLM
NOPQRSTUVW
XYZ
1234567890
!@#$%^& *()

BetaSans P.36

BetaSans Normal

ABCDEFGHIJ
KLMNOPQRS
TUVWXYZ
abcdefghijkl
mnopqrstuv
wxyz
1234567890
!@#$%^&*()

BetaSans Normal Oblique

ABCDEFGHIJ
KLMNOPQRS
TUVWXYZ
abcdefghijkl
mnopqrstuv
wxyz
1234567890
!@#$%^&()*

BetaSans P.36

BetaSans Normal

ABCDEFGHIJ
KLMNOPQRS
TUVWXYZ
abcdefghijkl
mnopqrstuv
wxyz
1234567890
!@#$%^&*()

BetaSans Normal Oblique

ABCDEFGHIJ
KLMNOPQRS
TUVWXYZ
abcdefghijkl
mnopqrstuv
wxyz
1234567890
!@#$%^&()*

BetaSans P.36

BetaSans Bold

ABCDEFGHIJ
KLMNOPQRS
TUVWXYZ
abcdefghijkl
mnopqrstuv
wxyz
1234567890
!@#$%^&*()

BetaSans Bold Oblique

ABCDEFGHIJ
KLMNOPQRS
TUVWXYZ
abcdefghijkl
mnopqrstuv
wxyz
1234567890
!@#$%^&*()

Blinddate Light

ABCDEFGHIJ
KLMNOPQR
STUVWXYZ

ABCDEFGHIJ
KLMNOPQR
STUVWXYZ
1234567890
! AT NO. $%^&*()

Blinddate Regular

ABCDEFGHIJ
KLMNOPQR
STUVWXYZ

ABCDEFGHIJ
KLMNOPQR
STUVWXYZ
1234567890
! AT NO. $%^&*()

Blinddate P.38

Blinddate Light

ABCDEFGHIJ
KLMNOPQR
STUVWXYZ

ABCDEFGHIJ
KLMNOPQR
STUVWXYZ
1234567890
! AT NO. $%^&*()

Blinddate Regular

ABCDEFGHIJ
KLMNOPQR
STUVWXYZ

ABCDEFGHIJ
KLMNOPQR
STUVWXYZ
1234567890
! AT NO. $%^&*()

Bodoni Open P.40

Bodoni Open

ABCDEFGHIJ
KLMNOPQRS
TUVWXYZ
abcdefghijkl
mnopqrstuv
wxyz
1234567890
!@#$%^&*()

Bokonon P.42

Bokonon

ABCDEFGH
IJKLMNOPQ
RSTUVWXYZ
abcdefghijklmn
opqrstuvwxyz
1234567890
!@#$%^&*()

Bodoni Open P.40

Bodoni Open

ABCDEFGHIJ
KLMNOPQRS
TUVWXYZ
abcdefghijkl
mnopqrstuv
wxyz
1234567890
!@#$%^&*()

Bokonon P.42

Bokonon

ABCDEFGH
IJKLMNOPQ
RSTUVWXYZ
abcdefghijklmn
opqrstuvwxyz
1234567890
!@#$%^&*()

Caslon Antiqua P.44

Caslon Antiqua

Caslon Antiqua P.44

Caslon Antiqua

ABCDEFGHIJ
KLMNOPQR
STUVWXYZ
abcdefghijklmn
opqrstuvwxyz
1234567890
!@#$%^&*()

Cholla P.46

Cholla Sans Regular

Cholla P.46

Cholla Sans Regular

ABCDEFGHIJKLMN
OPQRSTUVWXYZ
abcdefghijklmn
opqrstuvwxyz

Cholla Sans Bold

ABCDEFGHIJKLMN
OPQRSTUVWXYZ
abcdefghijklmn
opqrstuvwxyz

Cholla P.46

Cholla Slab Regular

ABCDEFGHIJK
LMNOPQRSTU
VWXYZ
abcdefghijkl
mnopqrstuv
wxyz

Cholla Slab Bold

ABCDEFGHIJK
LMNOPQRSTU
VWXYZ
abcdefghijkl
mnopqrstuv
wxyz

Cholla Unicase

ABCDEFGHIjKLMN
OPQRSTUVWXYZ
aBCDEFGHIjKLM
nopqrstuvwxyz

Cholla P.46

Cholla Slab Regular

ABCDEFGHIJK
LMNOPQRSTU
VWXYZ
abcdefghijkl
mnopqrstuv
wxyz

Cholla Slab Bold

ABCDEFGHIJK
LMNOPQRSTU
VWXYZ
abcdefghijkl
mnopqrstuv
wxyz

Cholla Unicase

ABCDEFGHIjKLMN
OPQRSTUVWXYZ
aBCDEFGHIjKLM
nopqrstuvwxyz

Cholla P.46

Cholla Unicase Ligatures

Ff Ft ga gi go gy
He Hi Ho In Ip
Is Ss It Ki Ky La
Le Lt Ly mR mS ge
gf gff go qu ra
re ro Si So Sp St
Ta T^A T^e TH TI TO
TOO TT TU TW TY
Un Up UT VA ZI ZO

ITC Coconino P.48

ITC Coconino

ABCDEFGHIJK
LMNOPQRSTU
VWXYZ
abcdefghijklmn
opqrstuvwxyz
1234567890
!@#$% ^ &*()

Coltrane P.50

Coltrane

ABCDEFGHIJKLMN
OPQRSTUVWXYZ
abcdefghijklmn
opqrstuvwxyz
1234567890
!#$?.^?*()

Cut It Out P.52

Cut It Out

ABCDEFGHIJKLMNO
PQRSTUVWXYZ
abcdefghijklmno
parstuvwxyz
1234567890
!@#$%&*()

Coltrane P.50

Coltrane

ABCDEFGHIJKLMN
OPQRSTUVWXYZ
abcdefghijklmn
opqrstuvwxyz
1234567890
!#$?.^?*()

Cut It Out P.52

Cut It Out

ABCDEFGHIJKLMNO
PQRSTUVWXYZ
abcdefghijklmno
parstuvwxyz
1234567890
!@#$%&*()

FF Dax Condensed Light

ABCDEFGHIJKLM
NOPQRSTUV
WXYZ
abcdefghijklmn
opqrstuvwxyz
1234567890
!@#$%^&*()

FF Dax Condensed Regular

ABCDEFGHIJKLM
NOPQRSTUV
WXYZ
abcdefghijklmn
opqrstuvwxyz
1234567890
!@#$%^&*()

FF **Dax Condensed** P.54

FF Dax Condensed Light

ABCDEFGHIJKLM
NOPQRSTUV
WXYZ
abcdefghijklmn
opqrstuvwxyz
1234567890
!@#$%^&*()

FF Dax Condensed Regular

ABCDEFGHIJKLM
NOPQRSTUV
WXYZ
abcdefghijklmn
opqrstuvwxyz
1234567890
!@#$%^&*()

FF Dax Condensed Medium

ABCDEFGHIJKLM
NOPQRSTUV
WXYZ
abcdefghijklmn
opqrstuvwxyz
1234567890
!@#$%^&*()

FF Dax Condensed Bold

ABCDEFGHIJKLM
NOPQRSTUV
WXYZ
abcdefghijklmn
opqrstuvwxyz
1234567890
!@#$%^&*()

FF **Dax Condensed** P.54

FF Dax Condensed Medium

ABCDEFGHIJKLM
NOPQRSTUV
WXYZ
abcdefghijklmn
opqrstuvwxyz
1234567890
!@#$%^&*()

FF Dax Condensed Bold

ABCDEFGHIJKLM
NOPQRSTUV
WXYZ
abcdefghijklmn
opqrstuvwxyz
1234567890
!@#$%^&*()

FF Dax Condensed ExtraBold

ABCDEFGHIJKL
MNOPQRSTUV
WXYZ
abcdefghijklm
nopqrstuvwxyz
1234567890
!@#$%^&*()

FF Dax Condensed Black

ABCDEFGHIJKL
MNOPQRSTUV
WXYZ
abcdefghijklm
nopqrstuvwxyz
1234567890
!@#$%^&*()

FF **Dax Condensed** P.54

FF Dax Condensed ExtraBold

ABCDEFGHIJKL
MNOPQRSTUV
WXYZ
abcdefghijklm
nopqrstuvwxyz
1234567890
!@#$%^&*()

FF Dax Condensed Black

ABCDEFGHIJKL
MNOPQRSTUV
WXYZ
abcdefghijklm
nopqrstuvwxyz
1234567890
!@#$%^&*()

Default Gothic P.56

Default Gothic P.56

Default Gothic A Gauge Upright

ABCDEFGHIJKL
MNOPQRSTUV
WXYZ
abcdefghijklmn
opqrstuvwxyz
1234567890
!@#$%^&*()

Default Gothic A Gauge Italic

ABCDEFGHIJKL
MNOPQRSTUV
WXYZ
abcdefghijklmn
opqrstuvwxyz
1234567890
!@#$%^&()*

Default Gothic A Gauge Upright

ABCDEFGHIJKL
MNOPQRSTUV
WXYZ
abcdefghijklmn
opqrstuvwxyz
1234567890
!@#$%^&*()

Default Gothic A Gauge Italic

ABCDEFGHIJKL
MNOPQRSTUV
WXYZ
abcdefghijklmn
opqrstuvwxyz
1234567890
!@#$%^&()*

Default Gothic P.56

Default Gothic B Gauge Upright

ABCDEFGHIJKL
MNOPQRSTUV
WXYZ
abcdefghijklmn
opqrstuvwxyz
1234567890
!@#$%^&*()

Default Gothic B Gauge Italic

ABCDEFGHIJKL
MNOPQRSTUV
WXYZ
abcdefghijklm
nopqrstuvwxyz
1234567890
!@#$%^&*()

Default Gothic P.56

Default Gothic B Gauge Upright

ABCDEFGHIJKL
MNOPQRSTUV
WXYZ
abcdefghijklmn
opqrstuvwxyz
1234567890
!@#$%^&*()

Default Gothic B Gauge Italic

ABCDEFGHIJKL
MNOPQRSTUV
WXYZ
abcdefghijklm
nopqrstuvwxyz
1234567890
!@#$%^&*()

Default Gothic P.56

Default Gothic C Gauge Upright

ABCDEFGHIJKL
MNOPQRSTUV
WXYZ
abcdefghijkl
mnopqrstuv
wxyz
1234567890
!@#$%^&*()

Default Gothic C Gauge Italic

ABCDEFGHIJKL
MNOPQRSTUV
WXYZ
abcdefghijkl
mnopqrstuv
wxyz
1234567890
!@#$%^&*()

Default Gothic P.56

Default Gothic C Gauge Upright

ABCDEFGHIJKL
MNOPQRSTUV
WXYZ
abcdefghijkl
mnopqrstuv
wxyz
1234567890
!@#$%^&*()

Default Gothic C Gauge Italic

ABCDEFGHIJKL
MNOPQRSTUV
WXYZ
abcdefghijkl
mnopqrstuv
wxyz
1234567890
!@#$%^&*()

Duchamp P.58

Duchamp

ABCDEFGHIJKL
MNOPQRSTUV
WXYZ
abcdefghijklmn
opqrstuvwxyz
1234567890
!#$%^&*()

DV9 P.60

DV9

ABCDEFGHIJ
KLMNOPQRS
TUVWXYZ
abcdefghijklmn
opqrstuvwxyz
1234567890
!#$%^&*()

Duchamp P.58

Duchamp

ABCDEFGHIJKL
MNOPQRSTUV
WXYZ
abcdefghijklmn
opqrstuvwxyz
1234567890
!#$%^&*()

DV9 P.60

DV9

ABCDEFGHIJ
KLMNOPQRS
TUVWXYZ
abcdefghijklmn
opqrstuvwxyz
1234567890
!#$%^&*()

Eidetic Neo P.62

Eidetic Neo Regular

ABCDEFGHIJK
LMNOPQRSTU
VWXYZ
abcdefghijklm
nopqrstuvwxyz
1234567890
!@#$%^&*()

Eidetic Neo Italic

ABCDEFGHIJK
LMNOPQRSTU
VWXYZ
abcdefghijklmn
opqrstuvwxyz
1234567890
!@#$%^&*()

Eidetic Neo P.62

Eidetic Neo Regular

ABCDEFGHIJK
LMNOPQRSTU
VWXYZ
abcdefghijklm
nopqrstuvwxyz
1234567890
!@#$%^&*()

Eidetic Neo Italic

ABCDEFGHIJK
LMNOPQRSTU
VWXYZ
abcdefghijklmn
opqrstuvwxyz
1234567890
!@#$%^&*()

Eidetic Neo Bold

ABCDEFGHIJK
LMNOPQRSTU
VWXYZ
abcdefghijklm
nopqrstuvwxyz
1234567890
!@#$%^&*()

Eidetic Neo Bold Italic

ABCDEFGHIJK
LMNOPQRSTU
VWXYZ
abcdefghijklm
nopqrstuvw
xyz
1234567890
!@#$%^&()*

Eidetic Neo P.62

Eidetic Neo Bold

ABCDEFGHIJK
LMNOPQRSTU
VWXYZ
abcdefghijklm
nopqrstuvwxyz
1234567890
!@#$%^&*()

Eidetic Neo Bold Italic

ABCDEFGHIJK
LMNOPQRSTU
VWXYZ
abcdefghijklm
nopqrstuvw
xyz
1234567890
!@#$%^&()*

Eidetic Neo Black

ABCDEFGHIJK
LMNOPQRSTU
VWXYZ
abcdefghijkl
mnopqrstuv
wxyz
1234567890
!@#$%^&*()

Eidetic Neo Smallcaps

ABCDEFGHIJK
LMNOPQRSTU
VWXYZ
ABCDEFGHIJKL
MNOPQRSTUV
WXYZ
1234567890
!@#$%^&*()

Eidetic Neo P.62

Eidetic Neo Black

ABCDEFGHIJK
LMNOPQRSTU
VWXYZ
abcdefghijkl
mnopqrstuv
wxyz
1234567890
!@#$%^&*()

Eidetic Neo Smallcaps

ABCDEFGHIJK
LMNOPQRSTU
VWXYZ
ABCDEFGHIJKL
MNOPQRSTUV
WXYZ
1234567890
!@#$%^&*()

Eidetic Neo P.62

Eidetic Neo Omni

ABCDEFGHIJK
LMNOPQRSTU
VWXYZ
abcdefghijk
Lmnopqrstu
vwxyz
1234567890
!@#$%^&*()

Eidetic Neo Fractions

✈ ⊕ © ♀ ⅇ ✉ ¼ ½
¾ ⅛ ⅜ ⅝ ⅞ ⅓ ⅔ ℗
♂ ® ♂ ☏ % ff fi fl ff ffi ffl
ABCDEFGHIJKL
MNOPQRSTUV
WXYZ
1234567890
1234567890

Eidetic Neo P.62

Eidetic Neo Omni

ABCDEFGHIJK
LMNOPQRSTU
VWXYZ
abcdefghijk
Lmnopqrstu
vwxyz
1234567890
!@#$%^&*()

Eidetic Neo Fractions

✈ ⊕ © ♀ ⅇ ✉ ¼ ½
¾ ⅛ ⅜ ⅝ ⅞ ⅓ ⅔ ℗
♂ ® ♂ ☏ % ff fi fl ff ffi ffl
ABCDEFGHIJKL
MNOPQRSTUV
WXYZ
1234567890
1234567890

Epicure P.64

Epicure Regular

ABCDEFGHJKLMN
OPQRSTUVWXYZ
ABCDEFGHIJKLMN
OPQRSTUVWXYZ
1234567890
!AT#$%^&*()

Epicure Alternate

ABCDEFGHJKLMN
OPQRSTUVWXYZ
ABCDEFGHIJKLMN
OPQRSTUVWXYZ
1234567890
!AT#$%^&*()

Epicure P.64

Epicure Regular

ABCDEFGHJKLMN
OPQRSTUVWXYZ
ABCDEFGHIJKLMN
OPQRSTUVWXYZ
1234567890
!AT#$%^&*()

Epicure Alternate

ABCDEFGHJKLMN
OPQRSTUVWXYZ
ABCDEFGHIJKLMN
OPQRSTUVWXYZ
1234567890
!AT#$%^&*()

EricsSome

EricsSome Normal

ABCDEFGHIJ
KLMNOPQRS
TUVWXYZ
abcdefghij
klmnopqrs
tuvwxyz
1234567890
!@#$%^&*()

EricsSome Pi

EricsSome Normal

ABCDEFGHIJ
KLMNOPQRS
TUVWXYZ
abcdefghij
klmnopqrs
tuvwxyz
1234567890
!@#$%^&*()

EricsSome Pi

Faceplate Sans P.68

Faceplate Sans A Gauge Upright

ABCDEFGHIJKL
MNOPQRSTUV
WXYZ
abcdefghijklmn
opqrstuvwxyz
1234567890
!@#$%^&*()

Faceplate Sans A Gauge Oblique

ABCDEFGHIJKL
MNOPQRSTUV
WXYZ
abcdefghijklmn
opqrstuvwxyz
1234567890
!@#$%^&()*

Faceplate Sans P.68

Faceplate Sans A Gauge Upright

ABCDEFGHIJKL
MNOPQRSTUV
WXYZ
abcdefghijklmn
opqrstuvwxyz
1234567890
!@#$%^&*()

Faceplate Sans A Gauge Oblique

ABCDEFGHIJKL
MNOPQRSTUV
WXYZ
abcdefghijklmn
opqrstuvwxyz
1234567890
!@#$%^&()*

Faceplate Sans P.68

Faceplate Sans B Gauge Upright

ABCDEFGHIJKL
MNOPQRSTUV
WXYZ
abcdefghijklmn
opqrstuvwxyz
1234567890
!@#$%^&*()

Faceplate Sans B Gauge Oblique

ABCDEFGHIJKL
MNOPQRSTUV
WXYZ
abcdefghijklmn
opqrstuvwxyz
1234567890
!@#$%^&*()

Faceplate Sans P.68

Faceplate Sans B Gauge Upright

ABCDEFGHIJKL
MNOPQRSTUV
WXYZ
abcdefghijklmn
opqrstuvwxyz
1234567890
!@#$%^&*()

Faceplate Sans B Gauge Oblique

ABCDEFGHIJKL
MNOPQRSTUV
WXYZ
abcdefghijklmn
opqrstuvwxyz
1234567890
!@#$%^&*()

Faceplate Sans P.68

Faceplate Sans C Gauge Upright

ABCDEFGHIJKL
MNOPQRSTUV
WXYZ
abcdefghijklmn
opqrstuvwxyz
1234567890
!@#$%^&*()

Faceplate Sans C Gauge Oblique

ABCDEFGHIJKL
MNOPQRSTUV
WXYZ
abcdefghijklmn
opqrstuvwxyz
1234567890
!@#$%^&*()

Faceplate Sans P.68

Faceplate Sans C Gauge Upright

ABCDEFGHIJKL
MNOPQRSTUV
WXYZ
abcdefghijklmn
opqrstuvwxyz
1234567890
!@#$%^&*()

Faceplate Sans C Gauge Oblique

ABCDEFGHIJKL
MNOPQRSTUV
WXYZ
abcdefghijklmn
opqrstuvwxyz
1234567890
!@#$%^&*()

Flurry P.70

Flurry Normal

ABCDEFGHIJ
KLMNOPQRS
TUVWXYZ.
abcdefghijklm
opqrstuvwxyz
1234567890
!@#$%^&*()

Flurry Heavy

ABCDEFGHIJ
KLMNOPQR
STUVWXYZ.
abcdefghijklm
nopqrstuv
wxyz
1234567890
!@#$%^&*()

Flurry P.70

Flurry Black

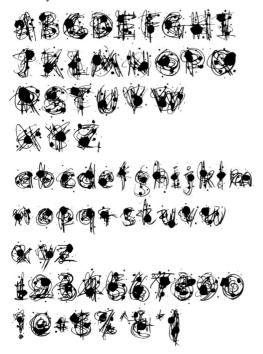

Fono P.72

Fono Medium

ABCDEFGHIJKL
MNOPQRSTUV
WXYZ
abcdefghijklmn
opqrstuvwxyz
1234567890
!@№$%^&*()

Flurry P.70

Flurry Black

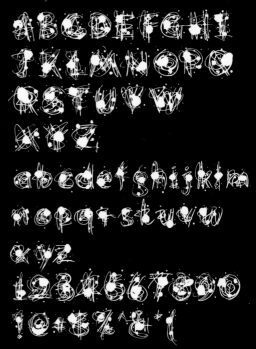

Fono P.72

Fono Medium

ABCDEFGHIJKL
MNOPQRSTUV
WXYZ
abcdefghijklmn
opqrstuvwxyz
1234567890
!@№$%^&*()

Fono P.72

Fono Medium Oblique

ABCDEFGHIJKL
MNOPQRSTUV
WXYZ
abcdefghijklm
nopqrstuvw
xyz
1234567890
!@№$%^&*()

Fono Medium Unicase

ABCDEFGHIJKL
MNOPQRSTUV
WXYZ
abcdefghijkl
mnopqrstuv
wxyz
1234567890
!@№$%^&*()

Fono P.72

Fono Medium Oblique

ABCDEFGHIJKL
MNOPQRSTUV
WXYZ
abcdefghijklm
nopqrstuvw
xyz
1234567890
!@№$%^&*()

Fono Medium Unicase

ABCDEFGHIJKL
MNOPQRSTUV
WXYZ
abcdefghijkl
mnopqrstuv
wxyz
1234567890
!@№$%^&*()

Fono P.72

Fono Medium Unicase Oblique

ABCDEFGHIJKL
MNOPQRSTUV
WXYZ
abcdefghijklm
nopqrstuvw
xyz
1234567890
!@№$%^&*()

Fono Compressed

ABCDEFGHIJKLMNOP
QRSTUVWXYZ
abcdefghijklmnop
qrstuvwxyz
1234567890
!@№$%^&*()

Fono P.72

Fono Medium Unicase Oblique

ABCDEFGHIJKL
MNOPQRSTUV
WXYZ
abcdefghijklm
nopqrstuvw
xyz
1234567890
!@№$%^&*()

Fono Compressed

ABCDEFGHIJKLMNOP
QRSTUVWXYZ
abcdefghijklmnop
qrstuvwxyz
1234567890
!@№$%^&*()

Fono P.72

Fono Compressed Oblique

ABCDEFGHIJKLMNOP
QRSTUVWXYZ
abcdefghijklmnop
qrstuvwxyz
1234567890
!@№$%^&*()

Fono Compressed Unicase

ABCDEFGHIJKLMNOP
QRSTUVWXYZ
abcdefghijklmnop
qrstuvwxyz
1234567890
!@№$%^&*()

Fono P.72

Fono Compressed Oblique

ABCDEFGHIJKLMNOP
QRSTUVWXYZ
abcdefghijklmnop
qrstuvwxyz
1234567890
!@№$%^&*()

Fono Compressed Unicase

ABCDEFGHIJKLMNOP
QRSTUVWXYZ
abcdefghijklmnop
qrstuvwxyz
1234567890
!@№$%^&*()

Fono P.72

Fono P.72

Fono Compressed Unicase Oblique

ABCDEFGHIJKLMNOP
QRSTUVWXYZ
abcdefghijklmnop
qrstuvwxyz
1234567890
!@№$%^&*()

Fono Compressed Unicase Oblique

ABCDEFGHIJKLMNOP
QRSTUVWXYZ
abcdefghijklmnop
qrstuvwxyz
1234567890
!@№$%^&*()

Fono Expanded

ABCDEFGHIJ
KLMNOPQRS
TUVWXYZ
abcdefghijk
lmnopqrstu
vwxyz
1234567890
!@№$%^&*()

Fono Expanded

ABCDEFGHIJ
KLMNOPQRS
TUVWXYZ
abcdefghijk
lmnopqrstu
vwxyz
1234567890
!@№$%^&*()

Fono P.72

Fono Expanded Oblique

ABCDEFGHIJ
KLMNOPQRS
TUVWXYZ
abcdefghijk
lmnopqrstu
vwxyz
1234567890
!@№$%^&*()

Fono Expanded Oblique

ABCDEFGHIJ
KLMNOPQRS
TUVWXYZ
abcdefghijk
lmnopqrstu
vwxyz
1234567890
!@№$%^&*()

Fono Expanded Unicase

ABCDEFGHIJ
KLMNOPQRS
TUVWXYZ
ABCDEFGHIJK
LMNOPQRSTU
VWXYZ
1234567890
!@№$%^&*()

Fono Expanded Unicase

ABCDEFGHIJ
KLMNOPQRS
TUVWXYZ
ABCDEFGHIJK
LMNOPQRSTU
VWXYZ
1234567890
!@№$%^&*()

Fono P.72

Fono Expanded Unicase Oblique

**ABCDEFGHIJ
KLMNOPQRS
TUVWXYZ
abcdefghijk
lmnopqrstu
vwxyz
1234567890
!@№$%^&*()**

Fonicons

Fono P.72

Fono Expanded Unicase Oblique

**ABCDEFGHIJ
KLMNOPQRS
TUVWXYZ
abcdefghijk
lmnopqrstu
vwxyz
1234567890
!@№$%^&*()**

Fonicons

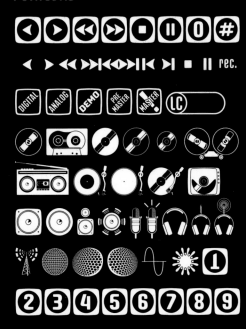

Freak P.74

Freak

ABCDEFGHIJ
KLMNOPQRST
UVWXYZ
abcdefghijklmn
opqrstuvwxyz
1234567890
!@#$%^&*()

Gas P.76

Gas

ABCDEFGHIJ
KLMNOPQR
STUVWXYZ
abcdefghij
klmnopqr
stuvwxyz
1234567890
!@#$%^G*()

Freak P.74

Freak

ABCDEFGHIJ
KLMNOPQRST
UVWXYZ
abcdefghijklmn
opqrstuvwxyz
1234567890
!@#$%^&*()

Gas P.76

Gas

ABCDEFGHIJ
KLMNOPQR
STUVWXYZ
abcdefghij
klmnopqr
stuvwxyz
1234567890
!@#$%^G*()

Gas P.76

Gas Lite

ABCDEFGHIJ
KLMNOPQR
STUVWXYZ
abcdefghij
klmnopqr
stuvwxyz
1234567890
!@#$%^G*()

Gunshot P.78

Gunshot

ABCDEFGHIJKL
MNOPQRSTUVW
XYZ
ABCDEFGHIJKL
MNOPQRSTUV
WXYZ
1234567890
!@#$%^&*()

Gas P.76

Gas Lite

ABCDEFGHIJ
KLMNOPQR
STUVWXYZ
abcdefghij
klmnopqr
stuvwxyz
1234567890
!@#$%^G*()

Gunshot P.78

Gunshot

ABCDEFGHIJKL
MNOPQRSTUVW
XYZ
ABCDEFGHIJKL
MNOPQRSTUV
WXYZ
1234567890
!@#$%^&*()

Hattrick P.80

Hattrick Regular

ABCDEFGHIJKL
MNOPQRSTUV
WXYZ
abcdefghijklmno
pqrstuvwxyz
1234567890
!@#$%^&*()

Hattrick Italic

ABCDEFGHIJKL
MNOPQRSTUV
WXYZ
abcdefghijklmno
pqrstuvwxyz
1234567890
!@#$%^&*()

Hattrick P.80

Hattrick Regular

ABCDEFGHIJKL
MNOPQRSTUV
WXYZ
abcdefghijklmno
pqrstuvwxyz
1234567890
!@#$%^&*()

Hattrick Italic

ABCDEFGHIJKL
MNOPQRSTUV
WXYZ
abcdefghijklmno
pqrstuvwxyz
1234567890
!@#$%^&*()

Hattrick P.80

Hattrick Bold

ABCDEFGHIJKL
MNOPQRSTUV
WXYZ
abcdefghijklmno
pqrstuvwxyz
1234567890
!@#$%^&*()

Hattrick Bold Italic

ABCDEFGHIJKL
MNOPQRSTUV
WXYZ
abcdefghijklmno
pqrstuvwxyz
1234567890
!@#$%^&*()

Hattrick P.80

Hattrick Bold

ABCDEFGHIJKL
MNOPQRSTUV
WXYZ
abcdefghijklmno
pqrstuvwxyz
1234567890
!@#$%^&*()

Hattrick Bold Italic

ABCDEFGHIJKL
MNOPQRSTUV
WXYZ
abcdefghijklmno
pqrstuvwxyz
1234567890
!@#$%^&*()

Hattrick P.80

Hattrick Small Caps &
Old Style Figures

ABCDEFGHIJKL
MNOPQRSTUV
WXYZ
ABCDEFGHIJKLMNO
PQRSTUVWXYZ
1234567890
!@#$%^&*()

ITC Humana P.82

Humana Serif Medium ITC

ABCDEFGHIJ
KLMNOPQR
STUVWXYZ
abcdefghijkl
mnopqrstuv
wxyz
1234567890
!@#$% ^ &*()

Hattrick P.80

Hattrick Small Caps &
Old Style Figures

ABCDEFGHIJKL
MNOPQRSTUV
WXYZ
ABCDEFGHIJKLMNO
PQRSTUVWXYZ
1234567890
!@#$%^&*()

ITC Humana P.82

Humana Serif Medium ITC

ABCDEFGHIJ
KLMNOPQR
STUVWXYZ
abcdefghijkl
mnopqrstuv
wxyz
1234567890
!@#$% ^ &*()

ITC **Humana** P.82

Humana Serif Medium Italic ITC

ABCDEFGHIJ
KLMNOPQRS
TUVWXYZ
abcdefghijklm
nopqrstuvwxyz
1234567890
!@#$% ^ &()*

Humana Serif Light ITC

ABCDEFGHIJK
LMNOPQRST
UVWXYZ
abcdefghijklmn
opqrstuvwxyz
1234567890
!@#$% ^ ℰ*()

ITC **Humana** P.82

Humana Serif Medium Italic ITC

ABCDEFGHIJ
KLMNOPQRS
TUVWXYZ
abcdefghijklm
nopqrstuvwxyz
1234567890
!@#$% ^ &()*

Humana Serif Light ITC

ABCDEFGHIJK
LMNOPQRST
UVWXYZ
abcdefghijklmn
opqrstuvwxyz
1234567890
!@#$% ^ ℰ*()

ITC Humana P.82

ITC Humana P.82

Humana Serif Light Italic ITC

ABCDEFGHIJK
LMNOPQRSTU
VWXYZ
abcdefghijklmno
pqrstuvwxyz
1234567890
!@#$%^&*()

Humana Serif Bold ITC

ABCDEFGHI
JKLMNOPQ
RSTUVW
XYZ
abcdefghijkl
mnopqrstuv
wxyz
1234567890
!@#$%^&*()

Humana Serif Bold Italic ITC

ABCDEFGHIJ
KLMNOPQRS
TUVWXYZ
abcdefghijklm
nopqrstuvw
xyz
1234567890
!@#$%^&*()

Humana Script Medium ITC

ABCDEFGHIJKL
MNOPQRSTUV
WXYZ
abcdefghijklmnopqrs
tuvwxyz
1234567890
!@#$%^&*()

Humana Script Light ITC

ABCDEFGHIJKL
MNOPQRSTUV
WXYZ
abcdefghijklmnopqrstu
vwxyz
1234567890
!@#$%^&*()

Humana Script Bold ITC

ABCDEFGHIJKL
MNOPQRSTUV
WXYZ
abcdefghijklmnopq
rstuvwxyz
1234567890
!@#$%^&*()

ITC **Humana** P.82

Humana Script Light ITC

ABCDEFGHIJKL
MNOPQRSTUV
WXYZ
abcdefghijklmnopqrstu
vwxyz
1234567890
!@#$%^&*()

Humana Script Bold ITC

ABCDEFGHIJKL
MNOPQRSTUV
WXYZ
abcdefghijklmnopq
rstuvwxyz
1234567890
!@#$%^&*()

Humana Sans Medium ITC

ABCDEFGHIJK
LMNOPQRST
UVWXYZ
abcdefghijklm
nopqrstuvw
xyz
1234567890
!@#$%^&*()

Humana Sans Medium Italic ITC

ABCDEFGHIJKL
MNOPQRSTUV
WXYZ
abcdefghijklm
nopqrstuvwxyz
1234567890
!@#$%^&*()

ITC **Humana** P.82

Humana Sans Medium ITC

ABCDEFGHIJK
LMNOPQRST
UVWXYZ
abcdefghijklm
nopqrstuvw
xyz
1234567890
!@#$%^&*()

Humana Sans Medium Italic ITC

ABCDEFGHIJKL
MNOPQRSTUV
WXYZ
abcdefghijklm
nopqrstuvwxyz
1234567890
!@#$%^&*()

Humana Sans Light ITC

ABCDEFGHIJKL
MNOPQRSTUV
WXYZ
abcdefghijklmn
opqrstuvwxyz
1234567890
!@#$%^&*()

Humana Sans Light Italic ITC

ABCDEFGHIJKL
MNOPQRSTUV
WXYZ
abcdefghijklmno
pqrstuvwxyz
1234567890
!@#$%^&*()

ITC **Humana** P.82

Humana Sans Light ITC

ABCDEFGHIJKL
MNOPQRSTUV
WXYZ
abcdefghijklmn
opqrstuvwxyz
1234567890
!@#$%^&*()

Humana Sans Light Italic ITC

ABCDEFGHIJKL
MNOPQRSTUV
WXYZ
abcdefghijklmno
pqrstuvwxyz
1234567890
!@#$%^&*()

Humana Sans Bold ITC

ABCDEFGHIJ
KLMNOPQR
STUVWXYZ
abcdefghijkl
mnopqrstuv
wxyz
1234567890
!@#$%^&*()

Humana Sans Bold Italic ITC

ABCDEFGHIJK
LMNOPQRST
UVWXYZ
abcdefghijklm
nopqrstuvw
xyz
1234567890
!@#$%^&*()

ITC **Humana** P.82

Humana Sans Bold ITC

ABCDEFGHIJ
KLMNOPQR
STUVWXYZ
abcdefghijkl
mnopqrstuv
wxyz
1234567890
!@#$%^&*()

Humana Sans Bold Italic ITC

ABCDEFGHIJK
LMNOPQRST
UVWXYZ
abcdefghijklm
nopqrstuvw
xyz
1234567890
!@#$%^&*()

Hydrous P.84

Hydrous Normal

ABCDEFGHIJKLM
NOPQRSTUVWXYZ
abcdefghijklmno
pqrstuvwxyz
1234567890
!@#$%^&*()

Hydrous Italic

ABCDEFGHIJKLM
NOPQRSTUVWXYZ
abcdefghijklmno
pqrstuvwxyz
1234567890
!@#$%^&*()

Hydrous P.84

Hydrous Normal

ABCDEFGHIJKLM
NOPQRSTUVWXYZ
abcdefghijklmno
pqrstuvwxyz
1234567890
!@#$%^&*()

Hydrous Italic

ABCDEFGHIJKLM
NOPQRSTUVWXYZ
abcdefghijklmno
pqrstuvwxyz
1234567890
!@#$%^&*()

Hydrous P.84

Hydrous Bold

ABCDEFGHIJKLM
NOPQRSTUVWXYZ
abcdefghijklmn
opqrstuvwxyz
1234567890
!@#$%^&*()

Hydrous Bold Italic

ABCDEFGHIJKL
MNOPQRSTUV
WXYZ
abcdefghijklmn
opqrstuvwxyz
1234567890
!@#$%^&*()

Hydrous P.84

Hydrous Bold

ABCDEFGHIJKLM
NOPQRSTUVWXYZ
abcdefghijklmn
opqrstuvwxyz
1234567890
!@#$%^&*()

Hydrous Bold Italic

ABCDEFGHIJKL
MNOPQRSTUV
WXYZ
abcdefghijklmn
opqrstuvwxyz
1234567890
!@#$%^&*()

Hydrous P.84

Hydrous Black

ABCDEFGHIJKL
MNOPQRSTUV
WXYZ
abcdefghijklmn
opqrstuvwxyz
1234567890
!@#$%^&*()

Hydrous Black Italic

ABCDEFGHIJKL
MNOPQRSTUV
WXYZ
abcdefghijklmn
opqrstuvwxyz
1234567890
!@#$%^&*()

Hydrous P.84

Hydrous Black

ABCDEFGHIJKL
MNOPQRSTUV
WXYZ
abcdefghijklmn
opqrstuvwxyz
1234567890
!@#$%^&*()

Hydrous Black Italic

ABCDEFGHIJKL
MNOPQRSTUV
WXYZ
abcdefghijklmn
opqrstuvwxyz
1234567890
!@#$%^&*()

Idiosynoptium P.86

Idiosynoptium 1.0

AbcdeFGhIJKL
mnopqrstu
vwxyz
abcdefghijkl
mnopqrstu
vwxyz
1234567890
!@#$%^&*()

Idiosynoptium 1.5

AbcdeFGhIJK
LmnopqrsT
uvwxyz
abcdefghijkl
mnopqrstu
vwxyz
1234567890
!@#$%^&*()

Idiosynoptium P.86

Idiosynoptium 1.0

AbcdeFGhIJKL
mnopqrstu
vwxyz
abcdefghijkl
mnopqrstu
vwxyz
1234567890
!@#$%^&*()

Idiosynoptium 1.5

AbcdeFGhIJK
LmnopqrsT
uvwxyz
abcdefghijkl
mnopqrstu
vwxyz
1234567890
!@#$%^&*()

Idiosynoptium P.86

Idiosynoptium 2.0

abcdefghijk
lmnopqrst
uvwxyz
abcdefghijk
lmnopqrst
uvwxyz
1234567890
!@#$%ˆ&*()

Index P.88

Index Light

ABCDEFGHIJKLM
NOPQRSTUVW
XYZ
abcdefghijklmno
pqrstuvwxyz
1234567890
!@#$%ˆ&*()

Idiosynoptium P.86

Idiosynoptium 2.0

abcdefghijk
lmnopqrst
uvwxyz
abcdefghijk
lmnopqrst
uvwxyz
1234567890
!@#$%ˆ&*()

Index P.88

Index Light

ABCDEFGHIJKLM
NOPQRSTUVW
XYZ
abcdefghijklmno
pqrstuvwxyz
1234567890
!@#$%ˆ&*()

Index Light Italic

ABCDEFGHIJKLMN
OPQRSTUVWXYZ
abcdefghijklmnop
qrstuvwxyz
1234567890
!@#$%^&()*

Index Book

ABCDEFGHIJKLM
NOPQRSTUVW
XYZ
abcdefghijklmnop
qrstuvwxyz
1234567890
!@#$%^&*()

Index P.88

Index Light Italic

ABCDEFGHIJKLMN
OPQRSTUVWXYZ
abcdefghijklmnop
qrstuvwxyz
1234567890
!@#$%^&()*

Index Book

ABCDEFGHIJKLM
NOPQRSTUVW
XYZ
abcdefghijklmnop
qrstuvwxyz
1234567890
!@#$%^&*()

Index Italic

ABCDEFGHIJKLMN
OPQRSTUVWXYZ
abcdefghijklmnop
qrstuvwxyz
1234567890
!@#$%^&()*

Index Bold

ABCDEFGHIJKL
MNOPQRSTUV
WXYZ
abcdefghijklmno
pqrstuvwxyz
1234567890
!@#$%^&*()

Index P.88

Index Italic

ABCDEFGHIJKLMN
OPQRSTUVWXYZ
abcdefghijklmnop
qrstuvwxyz
1234567890
!@#$%^&()*

Index Bold

ABCDEFGHIJKL
MNOPQRSTUV
WXYZ
abcdefghijklmno
pqrstuvwxyz
1234567890
!@#$%^&*()

Index Bold Italic

ABCDEFGHIJKLM
NOPQRSTUVW
XYZ
abcdefghijklmno
pqrstuvwxyz
1234567890
!@#$%^&()*

Index Expert Book

ABCDEFGHIJKLM
NOPQRSTUVW
XYZ
ABCDEFGHIJKLMN
OPQRSTUVWXYZ
1234567890
!@№$%^&*()

Index P.88

Index Bold Italic

ABCDEFGHIJKLM
NOPQRSTUVW
XYZ
abcdefghijklmno
pqrstuvwxyz
1234567890
!@#$%^&()*

Index Expert Book

ABCDEFGHIJKLM
NOPQRSTUVW
XYZ
ABCDEFGHIJKLMN
OPQRSTUVWXYZ
1234567890
!@№$%^&*()

Index Expert Italic

ABCDEFGHIJKLMN
OPQRSTUVWXYZ
ABCDEFGHIJKLMNOP
QRSTUVWXYZ
1234567890
!@№$%^&*()

Index Expert Bold

ABCDEFGHIJKLM
NOPQRSTUVW
XYZ
ABCDEFGHIJKLMN
OPQRSTUVWXYZ
1234567890
!@№$%^&*()

Index P.88

Index Expert Italic

ABCDEFGHIJKLMN
OPQRSTUVWXYZ
ABCDEFGHIJKLMNOP
QRSTUVWXYZ
1234567890
!@№$%^&*()

Index Expert Bold

ABCDEFGHIJKLM
NOPQRSTUVW
XYZ
ABCDEFGHIJKLMN
OPQRSTUVWXYZ
1234567890
!@№$%^&*()

Index Expert Bold Italic

ABCDEFGHIJKLMN
OPQRSTUVWXYZ
ABCDEFGHIJKLMNOP
QRSTUVWXYZ
1234567890
!@Nº$%^&*()

Index Book Alternate

AᴀᴬᴀᴱəɢGᴹᴮH Lᵀᴰ
ºQᴿṢtaᶜEʃgiᴸᴹ
ºℙᴿˢt⒰y!@$&Ɇ°()

Index Italic Alternate

A ᴀ ᴬ ᴀ Ɇ ə G GᴹᴮH
Lᵀᴰ º Q ᴿ Ṣ t
a ᶜ ᴱ ʃ g i ᴸ M
º ℙ ᴿ ˢ t ⒰ y
! @ $ & Ɇ ° ()

Index P.88

Index Expert Bold Italic

ABCDEFGHIJKLMN
OPQRSTUVWXYZ
ABCDEFGHIJKLMNOP
QRSTUVWXYZ
1234567890
!@Nº$%^&*()

Index Book Alternate

AᴀᴬᴀᴱəɢGᴹᴮH Lᵀᴰ
ºQᴿṢtaᶜEʃgiᴸᴹ
ºℙᴿˢt⒰y!@$&Ɇ°()

Index Italic Alternate

A ᴀ ᴬ ᴀ Ɇ ə G GᴹᴮH
Lᵀᴰ º Q ᴿ Ṣ t
a ᶜ ᴱ ʃ g i ᴸ M
º ℙ ᴿ ˢ t ⒰ y
! @ $ & Ɇ ° ()

Index Book Ligatures

cbchcicjckclct
rbrhrirjrkrlrt
sbshsisjskslst
obohoiojokaeae
ggghgiiolllioeof
oioofsfsssfififl
fjffiffifflffjff

Index Italic Ligatures

cbchcicjckclct
rbrhrirjrkrlrtsb
shsisjskslstoboh
oiojokaeaegggh
giiolllioeofoioofsfs
ssfififlfjffiffifflffiff

Index P.88

Index Book Ligatures

cbchcicjckclct
rbrhrirjrkrlrt
sbshsisjskslst
obohoiojokaeae
ggghgiiolllioeof
oioofsfsssfififl
fjffiffifflffjff

Index Italic Ligatures

cbchcicjckclct
rbrhrirjrkrlrtsb
shsisjskslstoboh
oiojokaeaegggh
giiolllioeofoioofsfs
ssfififlfjffiffifflffiff

Inhumaine P.90

Inhumaine Left

ABCDEEGHIJKLMNOPQ
RSTUVWXYZ
abcdefghijklmnopqrs
tuvwxyz
1234567890!@#$%^&*()

Inhumaine Center

ABCDEEGHIJKLMNOP
QRSTUVWXYZ
abcdefghijklmnopqr
stuvwxyz
1234567890!@#$%^&*()

Inhumaine Right

ABCDEFGHIJKLMNOPQ
RSTUVWXYZ
abcdefghijklmnopqrs
tuvwxyz
1234567890!@#$%^&*()

Inhumaine P.90

Inhumaine Left

ABCDEEGHIJKLMNOPQ
RSTUVWXYZ
abcdefghijklmnopqrs
tuvwxyz
1234567890!@#$%^&*()

Inhumaine Center

ABCDEEGHIJKLMNOP
QRSTUVWXYZ
abcdefghijklmnopqr
stuvwxyz
1234567890!@#$%^&*()

Inhumaine Right

ABCDEFGHIJKLMNOPQ
RSTUVWXYZ
abcdefghijklmnopqrs
tuvwxyz
1234567890!@#$%^&*()

Inhumaine P.90

Inhumaine Out Left

ABCDEFGHIJKLMNOP
QRSTUVWXYZ
abcdefghijklmnopqrst
uvwxyz
1234567890!@#$%^&*()

Inhumaine Out Center

ABCDEFGHIJKLMNOP
QRSTUVWXYZ
abcdefghijklmnopqrst
uvwxyz
1234567890!@#$%^&*()

Inhumaine Out Right

ABCDEFGHIJKLMNOP
QRSTUVWXYZ
abcdefghijklmnopqrst
uvwxyz
1234567890!@#$%^&*()

Inhumaine P.90

Inhumaine Out Left

ABCDEFGHIJKLMNOP
QRSTUVWXYZ
abcdefghijklmnopqrst
uvwxyz
1234567890!@#$%^&*()

Inhumaine Out Center

ABCDEFGHIJKLMNOP
QRSTUVWXYZ
abcdefghijklmnopqrst
uvwxyz
1234567890!@#$%^&*()

Inhumaine Out Right

ABCDEFGHIJKLMNOP
QRSTUVWXYZ
abcdefghijklmnopqrst
uvwxyz
1234567890!@#$%^&*()

Interrobang P.92

Interrobang Sans Regular

ABCDEFGHIJKLM
NOPQRSTUVWXYZ
abcdefghijklm
nopqrstuvwxyz
1234567890!@#$%^&*0

Interrobang Sans Bold

ABCDEFGHIJKLM
NOPQRSTUVWXYZ
abcdefghijklmn
opqrstuvwxyz
1234567890!@#$%^&*0

Interrobang Sans Inline

ABCDEFGHIJKLM
NOPQRSTUVWXYZ
abcdefghijklm
nopqrstuvwxyz
1234567890!@#$%^&*0

Interrobang P.92

Interrobang Sans Regular

ABCDEFGHIJKLM
NOPQRSTUVWXYZ
abcdefghijklm
nopqrstuvwxyz
1234567890!@#$%^&*0

Interrobang Sans Bold

ABCDEFGHIJKLM
NOPQRSTUVWXYZ
abcdefghijklmn
opqrstuvwxyz
1234567890!@#$%^&*0

Interrobang Sans Inline

ABCDEFGHIJKLM
NOPQRSTUVWXYZ
abcdefghijklm
nopqrstuvwxyz
1234567890!@#$%^&*0

Interrobang Sans Italic

ABCDEFGHIJKL
MNOPQRSTUV
WXYZ
abcdefghijklmn
opqrstuvwxyz
1234567890
!@#$%^&*()

Interrobang Serif Regular

ABCDEFGHIJKLM
NOPQRSTUVW
XYZ
abcdefghijklm
nopqrstuvw
xyz
1234567890
!@#$%^&*0

Interrobang P.92

Interrobang Sans Italic

ABCDEFGHIJKL
MNOPQRSTUV
WXYZ
abcdefghijklmn
opqrstuvwxyz
1234567890
!@#$%^&*()

Interrobang Serif Regular

ABCDEFGHIJKLM
NOPQRSTUVW
XYZ
abcdefghijklm
nopqrstuvw
xyz
1234567890
!@#$%^&*0

Interrobang P.92

Interrobang Serif Inline

ABCDEFGHIJKLM
NOPQRSTUVW
XYZ
abcdefghijklmn
opqrstuvwxyz
1234567890
!@≠$%^&*()

Jean Splice P.94

Jean Splice

ABCDEFGHIJ
KLMNOPQR
STUVWXYZ
ABCDEFGHIJ
KLMNOPQR
STUVWXYZ
1234567890
!@#$%^&*()

Interrobang P.92

Interrobang Serif Inline

ABCDEFGHIJKLM
NOPQRSTUVW
XYZ
abcdefghijklmn
opqrstuvwxyz
1234567890
!@≠$%^&*()

Jean Splice P.94

Jean Splice

ABCDEFGHIJ
KLMNOPQR
STUVWXYZ
ABCDEFGHIJ
KLMNOPQR
STUVWXYZ
1234567890
!@#$%^&*()

Jean Splice Lower Left

ABCDEFGHIJ
KLMNOPQR
STUVWXYZ
ABCDEFGHIJ
KLMNOPQR
STUVWXYZ
1234567890
!@#$%^&*()

Jean Splice Lower Left

ABCDEFGHIJ
KLMNOPQR
STUVWXYZ
ABCDEFGHIJ
KLMNOPQR
STUVWXYZ
1234567890
!@#$%^&*()

Jean Splice Lower Right

ABCDEFGHIJ
KLMNOPQR
STUVWXYZ
ABCDEFGHIJ
KLMNOPQR
STUVWXYZ
1234567890
!@#$%^&*()

Jean Splice Lower Right

ABCDEFGHIJ
KLMNOPQR
STUVWXYZ
ABCDEFGHIJ
KLMNOPQR
STUVWXYZ
1234567890
!@#$%^&*()

Jean Splice P.94

Jean Splice Up Left

ABCDEFGHIJ
KLMNOPQR
STUVWXYZ
ABCDEFGHIJ
KLMNOPQR
STUVWXYZ
1234567890
!@#$%^&*()

Jean Splice Up Right

ABCDEFGHIJ
KLMNOPQR
STUVWXYZ
ABCDEFGHIJ
KLMNOPQR
STUVWXYZ
1234567890
!@#$%^&*()

Jean Splice P.94

Jean Splice Up Left

ABCDEFGHIJ
KLMNOPQR
STUVWXYZ
ABCDEFGHIJ
KLMNOPQR
STUVWXYZ
1234567890
!@#$%^&*()

Jean Splice Up Right

ABCDEFGHIJ
KLMNOPQR
STUVWXYZ
ABCDEFGHIJ
KLMNOPQR
STUVWXYZ
1234567890
!@#$%^&*()

ITC Johanna Sparkling P.96

ITC Johanna Sparkling

ABCDEFGH
IJKLMNOP
QRSTUVW
XYZ

abcdefghijklmnopq

rstuvwyz

1234567890

!@#$%^ &()*

ITC Johanna Sparkling

Killer Ants P.98

Killer Ants P.98

Killer Ants

**ABCDEFG HIJKLMN
OPQRSTUVWXYZ
abcdefghijklmno
pqrstuvwxyz
1234567890
!@#$%^&*()**

Killer Ants

236

Killer Ants P.98

Killer Ants Bold

ABCDEFGHIJKLM
NOPQRSTUVW
XYZ
abcdefghijklm
nopqrstuvwxyz
1234567890
!@#$%^&*()

KO Dirty P.100

KO Dirty

ABCDEFGHIJKL
MNOPQRSTUV
WXYZ
abcdefghijklmnop
qrstuvwxyz
1234567890
!@#$%^&*()

Killer Ants P.98

Killer Ants Bold

ABCDEFGHIJKLM
NOPQRSTUVW
XYZ
abcdefghijklm
nopqrstuvwxyz
1234567890
!@#$%^&*()

KO Dirty P.100

KO Dirty

ABCDEFGHIJKL
MNOPQRSTUV
WXYZ
abcdefghijklmnop
qrstuvwxyz
1234567890
!@#$%^&*()

Malcom P.102

Malcom Regular

ABCDEFGHIJKL
MNOPQRSTUV
WXYZ
abcdefghijklm
nopqrstuvw
xyz
1234567890
!@#$%^&*()

Malcom Italic

ABCDEFGHIJKL
MNOPQRSTUV
WXYZ
abcdefghijklm
nopqrstuvw
xyz
1234567890
!@#$%^&*()

Malcom P.102

Malcom Regular

ABCDEFGHIJKL
MNOPQRSTUV
WXYZ
abcdefghijklm
nopqrstuvw
xyz
1234567890
!@#$%^&*()

Malcom Italic

ABCDEFGHIJKL
MNOPQRSTUV
WXYZ
abcdefghijklm
nopqrstuvw
xyz
1234567890
!@#$%^&*()

Malcom P.102

Malcom Medium

ABCDEFGHIJK
LMNOPQRSTU
VWXYZ
abcdefghijkl
mnopqrstuv
wxyz
1234567890
!@#$%^&*()

Malcom Medium Italic

ABCDEFGHIJK
LMNOPQRSTU
VWXYZ
abcdefghijkl
mnopqrstuv
wxyz
1234567890
!@#$%^&()*

Malcom P.102

Malcom Medium

ABCDEFGHIJK
LMNOPQRSTU
VWXYZ
abcdefghijkl
mnopqrstuv
wxyz
1234567890
!@#$%^&*()

Malcom Medium Italic

ABCDEFGHIJK
LMNOPQRSTU
VWXYZ
abcdefghijkl
mnopqrstuv
wxyz
1234567890
!@#$%^&()*

Malcom Bold

ABCDEFGHIJK
LMNOPQRSTU
VWXYZ
abcdefghijkl
mnopqrstuv
wxyz
1234567890
!@#$%^&*()

Malcom Bold Italic

ABCDEFGHIJKL
MNOPQRSTUV
WXYZ
abcdefghijklm
nopqrstuvw
xyz
1234567890
!@#$%^&*()

Malcom P.102

Malcom Bold

ABCDEFGHIJK
LMNOPQRSTU
VWXYZ
abcdefghijkl
mnopqrstuv
wxyz
1234567890
!@#$%^&*()

Malcom Bold Italic

ABCDEFGHIJKL
MNOPQRSTUV
WXYZ
abcdefghijklm
nopqrstuvw
xyz
1234567890
!@#$%^&*()

Midlaw P.104

Midlaw

ABCDEFGH
IJKLMNOPQ
RSTUVWXYZ
abcdefghijkl
mnopqrstuv
wxyz
1234567890
!@#$%^&*()

Mobilette P.106

Mobilette Regular

ABCDEFGHIJKLM
NOPQRSTUVWXYZ
abcdefghijklmn
opqrstuvwxyz
1234567890
!@#$%^&*()

Midlaw P.104

Midlaw

ABCDEFGH
IJKLMNOPQ
RSTUVWXYZ
abcdefghijkl
mnopqrstuv
wxyz
1234567890
!@#$%^&*()

Mobilette P.106

Mobilette Regular

ABCDEFGHIJKLM
NOPQRSTUVWXYZ
abcdefghijklmn
opqrstuvwxyz
1234567890
!@#$%^&*()

Mobilette P.106

Mobilette Italic

ABCDEFGHIJKLM
NOPQRSTUVW
XYZ
abcdefghijklm
nopqrstuvwxyz
1234567890
!@#$%^&*()

Mobilette Gas

ABCDEFGHIJ
KLMNOPQRST
UVWXYZ
abcdefghijk
lmnopqrstu
vwxyz
1234567890
!@#$%^&*()

Mobilette P.106

Mobilette Italic

ABCDEFGHIJKLM
NOPQRSTUVW
XYZ
abcdefghijklm
nopqrstuvwxyz
1234567890
!@#$%^&*()

Mobilette Gas

ABCDEFGHIJ
KLMNOPQRST
UVWXYZ
abcdefghijk
lmnopqrstu
vwxyz
1234567890
!@#$%^&*()

Mobilette P.106

Mobilette Oil

ABCDEFGHIJ
KLMNOPQRST
UVWXYZ
abcdefghijk
lmnopqrstu
vwxyz
1234567890
!@#$%^&*()

Mobilette Air

ABCDEFGHIJ
KLMNOPQRST
UVWXYZ
abcdefghijk
lmnopqrstu
vwxyz
1234567890
!@#$%^&*()

Mobilette P.106

Mobilette Oil

ABCDEFGHIJ
KLMNOPQRST
UVWXYZ
abcdefghijk
lmnopqrstu
vwxyz
1234567890
!@#$%^&*()

Mobilette Air

ABCDEFGHIJ
KLMNOPQRST
UVWXYZ
abcdefghijk
lmnopqrstu
vwxyz
1234567890
!@#$%^&*()

Mobilette P.106

Mobilette Pneu

ABCDEFGHIJ
KLMNOPQRS
TUVWXYZ
abcdefghij
klmnopqrst
uvwxyz
1234567890
!@#$%^&*()

Mobilette Script

ABCDEFGHIJKL
MNOPQRSTUVW
XYZ
abcdefghijkl
mnopqrstuvw
xyz
1234567890
!@#$%^&*()

Mobilette P.106

Mobilette Pneu

ABCDEFGHIJ
KLMNOPQRS
TUVWXYZ
abcdefghij
klmnopqrst
uvwxyz
1234567890
!@#$%^&*()

Mobilette Script

ABCDEFGHIJKL
MNOPQRSTUVW
XYZ
abcdefghijkl
mnopqrstuvw
xyz
1234567890
!@#$%^&*()

Monako P.108

Monako Serif

ABCDEFGHIJ
KLMNOPQRST
UVWXYZ
abcdefghij
klmnopqrst
uvwxyz
1234567890
!@#$%^&*()

Monako Sans

ABCDEFGHIJ
KLMNOPQRS
TUVWXYZ
abcdefghij
klmnopqrs
tuvwxyz
1234567890
!@#$%^&*()

Monako P.108

Monako Serif

ABCDEFGHIJ
KLMNOPQRST
UVWXYZ
abcdefghij
klmnopqrst
uvwxyz
1234567890
!@#$%^&*()

Monako Sans

ABCDEFGHIJ
KLMNOPQRS
TUVWXYZ
abcdefghij
klmnopqrs
tuvwxyz
1234567890
!@#$%^&*()

New Clear Era Regular

ABCDEFGHIJ
KLMNOPQRS
TUVWXYZ
abcdefghijklm
nopqrstuvwxyz
1234567890
!@#$%^&*()

New Clear Era Display One

ABCDEFGHIJ
KLMNOPQRS
TUVWXYZ
abcdefghijklm
nopqrstuvwxyz
1234567890
!@#$%^&*()

New Clear Era P.110

New Clear Era Regular

ABCDEFGHIJ
KLMNOPQRS
TUVWXYZ
abcdefghijklm
nopqrstuvwxyz
1234567890
!@#$%^&*()

New Clear Era Display One

ABCDEFGHIJ
KLMNOPQRS
TUVWXYZ
abcdefghijklm
nopqrstuvwxyz
1234567890
!@#$%^&*()

New Clear Era Display Two

ABCDEFGHIJ
KLMNOPQR
STUVWXYZ
abcdefghijklm
nopqrstuvw
xyz
1234567890
!@#$%^&*()

New Clear Era Display Caps

ABCDEFGHIJ
KLMNOPQRS
TUVWXYZ
ABCDEFGHIJ
KLMNOPQR
STUVWXYZ
1234567890
!@#$%^&*()

New Clear Era P.110

New Clear Era Display Two

ABCDEFGHI
KLMNOPQR
STUVWXYZ
abcdefghijkl
nopqrstuvw
xyz
1234567890
!@#$%^&*()

New Clear Era Display Caps

ABCDEFGHIJ
KLMNOPQRS
TUVWXYZ
ABCDEFGHI
KLMNOPQR
STUVWXYZ
1234567890
!@#$%^&*()

New Paroxysm P.112

New Paroxysm 1.0

ABCDEFGHIJKL
MNOPQRSTU
VWXYZ
abcdefghijklmn
opqrstuvwxyz
1234567890
!@#$%^&*()

New Paroxysm 1.1

ABCDEFGHIJ
KLMNOPQR
STUVWXYZ
abcdefghijkl
mnopqrstuv
wxyz
1234567890
!@#$%^&*()

New Paroxysm P.112

New Paroxysm 1.0

ABCDEFGHIJKL
MNOPQRSTU
VWXYZ
abcdefghijklmn
opqrstuvwxyz
1234567890
!@#$%^&*()

New Paroxysm 1.1

ABCDEFGHIJ
KLMNOPQR
STUVWXYZ
abcdefghijkl
mnopqrstuv
wxyz
1234567890
!@#$%^&*()

New Paroxysm 2.0

ABCDEFGHIJKL
MNOPQRSTU
VWXYZ
abcdefghijklmn
opqrstuvwxyz
1234567890
!@#$%ˆ&*()

New Paroxysm 2.0

ABCDEFGHIJKL
MNOPQRSTU
VWXYZ
abcdefghijklmn
opqrstuvwxyz
1234567890
!@#$%ˆ&*()

New Paroxysm 2.1

**ABCDEFGHIJ
KLMNOPQRS
TUVWXYZ
abcdefghijkl
mnopqrstuv
wxyz
1234567890
!@#$%ˆ&*()**

New Paroxysm 2.1

**ABCDEFGHIJ
KLMNOPQRS
TUVWXYZ
abcdefghijkl
mnopqrstuv
wxyz
1234567890
!@#$%ˆ&*()**

Newt P.114

Newt Regular

ABCDEFGHIJKLMN
OPQRSTUVWXYZ
abcdefghijklmn
opqrstuvwxyz
1234567890
!@#$%^&*()

Newt Italic

ABCDEFGHIJKLM
NOPQRSTUVWXYZ
abcdefghijklmn
opqrstuvwxyz
1234567890
!@#$%^&*()

Newt Bold

ABCDEFGHIJKLM
NOPQRSTUVWXYZ
abcdefghijklmn
opqrstuvwxyz
1234567890
!@#$%^&*()

Newt P.114

Newt Regular

ABCDEFGHIJKLMN
OPQRSTUVWXYZ
abcdefghijklmn
opqrstuvwxyz
1234567890
!@#$%^&*()

Newt Italic

ABCDEFGHIJKLM
NOPQRSTUVWXYZ
abcdefghijklmn
opqrstuvwxyz
1234567890
!@#$%^&*()

Newt Bold

ABCDEFGHIJKLM
NOPQRSTUVWXYZ
abcdefghijklmn
opqrstuvwxyz
1234567890
!@#$%^&*()

Newt Bold Italic

ABCDEFGHIJKLM
NOPQRSTUVWXYZ
abcdefghijklmn
opqrstuvwxyz
1234567890
!@#$%^&*()

Newt Mono Regular

ABCDEFGHIJKLM
NOPQRSTUVWXYZ
abcdefghijklm
nopqrstuvwxyz
1234567890
!@#$%^&*()

Newt Mono Corroded Light

ABCDEFGHIJKLM
NOPQRSTUVWXYZ
abcdefghijklm
nopqrstuvwxyz
1234567890
!@#$%^&*()

Newt P.114

Newt Bold Italic

ABCDEFGHIJKLM
NOPQRSTUVWXYZ
abcdefghijklmn
opqrstuvwxyz
1234567890
!@#$%^&*()

Newt Mono Regular

ABCDEFGHIJKLM
NOPQRSTUVWXYZ
abcdefghijklm
nopqrstuvwxyz
1234567890
!@#$%^&*()

Newt Mono Corroded Light

ABCDEFGHIJKLM
NOPQRSTUVWXYZ
abcdefghijklm
nopqrstuvwxyz
1234567890
!@#$%^&*()

Newt P.114

Newt Mono Corroded Heavy

ABCDEFGHIJKLM
NOPQRSTUVWXYZ
abcdefghijklm
nopqrstuvwxyz
1234567890
!@#$%ˆ`ε˙()

Not Caslon P.116

Not Caslon One

ABCDEFGHIJK
LMNOPQRSTU
VWXYZ
ABCDEFGHIJKL
MNOPQRSTUVW
XYZ123456789
0&

Newt P.114

Newt Mono Corroded Heavy

ABCDEFGHIJKLM
NOPQRSTUVWXYZ
abcdefghijklm
nopqrstuvwxyz
1234567890
!@#$%ˆ`ε˙()

Not Caslon P.116

Not Caslon One

ABCDEFGHIJK
LMNOPQRSTU
VWXYZ
ABCDEFGHIJKL
MNOPQRSTUVW
XYZ123456789
0&

Nuephoric P.118

Nuephoric P.118

Nuephoric Regular

Nuephoric Regular

Nuephoric Regular Italic

Nuephoric Regular Italic

Nuephoric Thin

Nuephoric Thin

Nuephoric Thin Italic

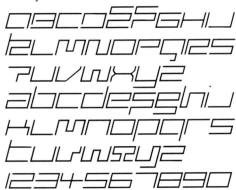

Nuephoric Heavy

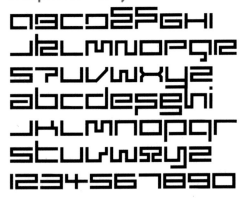

Nuephoric Heavy Italic

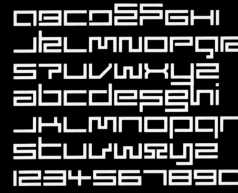

Nuephoric P.118

Nuephoric Thin Italic

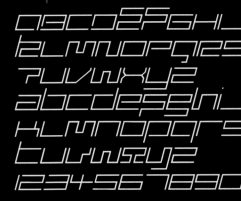

Nuephoric Heavy

Nuephoric Heavy Italic

Oxtail P.120

Oxtail Medium

ABCDEFGHIJ
KLMNOPQRS
TUVWXYZ
abcdefghijklm
nopqrstuvwxyz
1234567890
!@#$%^&*()

Oxtail Medium Italic

*ABCDEFGHIJ
KLMNOPQRS
TUVWXYZ
abcdefghijklm
nopqrstuvwxyz
1234567890
!@#$%^&*()*

Oxtail P.120

Oxtail Medium

ABCDEFGHIJ
KLMNOPQRS
TUVWXYZ
abcdefghijklm
nopqrstuvwxyz
1234567890
!@#$%^&*()

Oxtail Medium Italic

*ABCDEFGHIJ
KLMNOPQRS
TUVWXYZ
abcdefghijklm
nopqrstuvwxyz
1234567890
!@#$%^&*()*

Oxtail P.120

Oxtail Bold

ABCDEFGHIJ
KLMNOPQRS
TUVWXYZ
abcdefghijklm
nopqrstuv
wxyz
1234567890
!@#$%^&*()

Oxtail Bold Italic

ABCDEFGHIJ
KLMNOPQRS
TUVWXYZ
abcdefghijklm
nopqrstuvwxyz
1234567890
!@#$%^&()*

Oxtail P.120

Oxtail Bold

ABCDEFGHIJ
KLMNOPQRS
TUVWXYZ
abcdefghijklm
nopqrstuv
wxyz
1234567890
!@#$%^&*()

Oxtail Bold Italic

ABCDEFGHIJ
KLMNOPQRS
TUVWXYZ
abcdefghijklm
nopqrstuvwxyz
1234567890
!@#$%^&()*

Oxtail P.120

Oxtail Black

ABCDEFGHI
JKLMNOPQ
RSTUVWXYZ
abcdefghijkl
mnopqrstuv
wxyz
1234567890
!@#$%^&*()

Oxtail Black Italic

ABCDEFGHIJ
KLMNOPQRS
TUVWXYZ
abcdefghijkl
mnopqrstuv
wxyz
1234567890
!@#$%^&*()

Oxtail P.120

Oxtail Black

ABCDEFGHI
JKLMNOPQ
RSTUVWXYZ
abcdefghijkl
mnopqrstuv
wxyz
1234567890
!@#$%^&*()

Oxtail Black Italic

ABCDEFGHIJ
KLMNOPQRS
TUVWXYZ
abcdefghijkl
mnopqrstuv
wxyz
1234567890
!@#$%^&*()

Percolator P.122

Percolator Bold

ABCDEFGHIJKL
MNOPQRSTUVW
XYZ
abcdefghijklm
nopqrstuvw
xyz
1234567890
!@no$%^&*()

Percolator Regular

ABCDEFGHIJKL
MNOPQRSTUVW
XYZ
abcdefghijklm
nopqrstuvw
xyz
1234567890
!@no$%^&*()

Percolator P.122

Percolator Bold

ABCDEFGHIJKL
MNOPQRSTUVW
XYZ
abcdefghijklm
nopqrstuvw
xyz
1234567890
!@no$%^&*()

Percolator Regular

ABCDEFGHIJKL
MNOPQRSTUVW
XYZ
abcdefghijklm
nopqrstuvw
xyz
1234567890
!@no$%^&*()

Percolator P.122

Percolator Expert

ABCDEFGHIJ
KLMNOPQRS
TUVWXYZ

ABCDEFGHIJKLM
NOPQRSTUVWXYZ
1234567890
!Ⓐɴᴏ$%^&*()

Percolator Text

ABCDEFGHIJ
KLMNOPQR
STUVWXYZ

abcdefghijkſ
mnopqrstuv
wxyz
1234567890
!@ɴᴏ$%^&*()

Percolator P.122

Percolator Expert

ABCDEFGHIJ
KLMNOPQRS
TUVWXYZ

ABCDEFGHIJKLM
NOPQRSTUVWXYZ
1234567890
!Ⓐɴᴏ$%^&*()

Percolator Text

ABCDEFGHIJ
KLMNOPQR
STUVWXYZ

abcdefghijkſ
mnopqrstuv
wxyz
1234567890
!@ɴᴏ$%^&*()

Plankton-b P.124

Plankton-b

A.BCDEFGHIJ
KLMNOPQRS
TUVWXYZ
abcdefghijklmn
opqrstuvwxyz
1234567890
!@#$%^&*()

Poor Richard P.126

Poor Richard

ABCDEFGHI
JKLMNOPQR
STUVWXYZ
abcdefghijklm
nopqrstuvwxyz
1234567890
!@#$%^&*()

Plankton-b P.124

Plankton-b

A.BCDEFGHIJ
KLMNOPQRS
TUVWXYZ
abcdefghijklmn
opqrstuvwxyz
1234567890
!@#$%^&*()

Poor Richard P.126

Poor Richard

ABCDEFGHI
JKLMNOPQR
STUVWXYZ
abcdefghijklm
nopqrstuvwxyz
1234567890
!@#$%^&*()

Porno P.128

Porno Hard

ΛBCDEFGHI
JKLMNOPQR
STUVWXYZ
abcdefghi
jklmnopqr
stuvwxyz
1234567890
!@#$%^&*()

Porno Soft

ΛBCDEFGHI
JKLMNOPQR
STUVWXYZ
abcdefghi
jklmnopqr
stuvwxyz
1234567890
!@#$%^&*()

Porno P.128

Porno Hard

ΛBCDEFGHI
JKLMNOPQR
STUVWXYZ
abcdefghi
jklmnopqr
stuvwxyz
1234567890
!@#$%^&*()

Porno Soft

ΛBCDEFGHI
JKLMNOPQR
STUVWXYZ
abcdefghi
jklmnopqr
stuvwxyz
1234567890
!@#$%^&*()

Porno P.128

Porno Kinky

ABCDEFGHIJ
KLMNOPQRST
UVWXYZ
abcdefghij
klmnopqrst
uvwxyz
1234567890
!@#$%^&*()

Porno Kinky SM

ABCDEFGHIJ
KLMNOPQRST
UVWXYZ
abcdefghij
klmnopqrst
uvwxyz
1234567890
!@#$%^&*()

Porno P.128

Porno Kinky

ABCDEFGHIJ
KLMNOPQRST
UVWXYZ
abcdefghij
klmnopqrst
uvwxyz
1234567890
!@#$%^&*()

Porno Kinky SM

ABCDEFGHIJ
KLMNOPQRST
UVWXYZ
abcdefghij
klmnopqrst
uvwxyz
1234567890
!@#$%^&*()

PostMono P.130

Post Mono Medium

ABCDEFGHIJKLM
NOPQRSTUVWXYZ
abcdefghijklm
nopqrstuvwxyz
1234567890
!@#$%^&*()

Post Mono Light

ABCDEFGHIJKLM
NOPQRSTUVWXYZ
abcdefghijklm
nopqrstuvwxyz
1234567890
!@#$%^&*()

Post Mono Normal

ABCDEFGHIJKLM
NOPQRSTUVWXYZ
abcdefghijklm
nopqrstuvwxyz
1234567890
!@#$%^&*()

PostMono P.130

Post Mono Medium

ABCDEFGHIJKLM
NOPQRSTUVWXYZ
abcdefghijklm
nopqrstuvwxyz
1234567890
!@#$%^&*()

Post Mono Light

ABCDEFGHIJKLM
NOPQRSTUVWXYZ
abcdefghijklm
nopqrstuvwxyz
1234567890
!@#$%^&*()

Post Mono Normal

ABCDEFGHIJKLM
NOPQRSTUVWXYZ
abcdefghijklm
nopqrstuvwxyz
1234567890
!@#$%^&*()

PostMono P.130

Post Mono Bold

ABCDEFGHIJKLM
NOPQRSTUVWXYZ
abcdefghijklm
nopqrstuvwxyz
1234567890
!@#$%^&*()

Post Mono Black

ABCDEFGHIJKLM
NOPQRSTUVWXYZ
abcdefghijklm
nopqrstuvwxyz
1234567890
!@#$%^&*()

Punctual P.132

Punctual Universal Four

ABCDEFGHIJKLM
NOPQRSTUVWXYZ
abcdefghijklm
nopqrstuvwxyz
1234567890
!@#$%^&*()

PostMono P.130

Post Mono Bold

ABCDEFGHIJKLM
NOPQRSTUVWXYZ
abcdefghijklm
nopqrstuvwxyz
1234567890
!@#$%^&*()

Post Mono Black

ABCDEFGHIJKLM
NOPQRSTUVWXYZ
abcdefghijklm
nopqrstuvwxyz
1234567890
!@#$%^&*()

Punctual P.132

Punctual Universal Four

ABCDEFGHIJKLM
NOPQRSTUVWXYZ
abcdefghijklm
nopqrstuvwxyz
1234567890
!@#$%^&*()

Punctual Four

ABCDEFGHIJKLM
NOPQRSTUVWXYZ
abcdefghijklm
nopqrstuvwxyz
1234567890
!@#$%^&*()

Punctual Four Inline

ABCDEFGHIJKLM
NOPQRSTUVWXYZ
abcdefghijklm
nopqrstuvwxyz
1234567890
!@#$%^&*()

Punctual Four Interior

ABCDEFGHIJKLM
NOPQRSTUVWXYZ
abcdefghijklm
nopqrstuvwxyz
1234567890
!@#$%^&*()

Punctual P.132

Punctual Four

ABCDEFGHIJKLM
NOPQRSTUVWXYZ
abcdefghijklm
nopqrstuvwxyz
1234567890
!@#$%^&*()

Punctual Four Inline

ABCDEFGHIJKLM
NOPQRSTUVWXYZ
abcdefghijklm
nopqrstuvwxyz
1234567890
!@#$%^&*()

Punctual Four Interior

ABCDEFGHIJKLM
NOPQRSTUVWXYZ
abcdefghijklm
nopqrstuvwxyz
1234567890
!@#$%^&*()

Raven

ABCDEFGHIJKLMN
OPQRSTUVWXYZ
abcdefghijklmnopq
rstuvwxyz
1234567890
!#$%&*()

Raven EverMore

ABCDEFGHIJKLM
NOPQRSTUVWXYZ
abcdefghijklmnop
qrstuvwxyz
1234567890
!#$%&*()

Raven P.134

Raven

ABCDEFGHIJKLMN
OPQRSTUVWXYZ
abcdefghijklmnopq
rstuvwxyz
1234567890
!#$%&*()

Raven EverMore

ABCDEFGHIJKLM
NOPQRSTUVWXYZ
abcdefghijklmnop
qrstuvwxyz
1234567890
!#$%&*()

Requiem P.136

Requiem Dies Irae 1.0

ABCDEFGHIJ
KLMNOPQR
STUVWXYZ
ABCDEFGHIJK
LMNOPQRST
UVWXYZ
1234567890
!@#$%^&*()

Requiem Dies Irae 1.0

ABCDEFGHIJ
KLMNOPQR
STUVWXYZ
ABCDEFGHIJK
LMNOPQRST
UVWXYZ
1234567890
!@#$%^&*()

Requiem Dies Irae 1.1

ABCDEFGHIJ
KLMNOPQR
STUVWXYZ
ABCDEFGHIJ
KLMNOPQRS
TUVWXYZ
1234567890
!@#$%^&*()

Requiem Dies Irae 1.1

ABCDEFGHIJ
KLMNOPQR
STUVWXYZ
ABCDEFGHIJ
KLMNOPQRS
TUVWXYZ
1234567890
!@#$%^&*()

Requiem Simplex 2.0

ABCDEFGHIJK
LMNOPQRS
TUVWXYZ
ABCDEFGHIJKL
MNOPQRSTU
VWXYZ
1234567890
!@#$%^&*()

Requiem Simplex 2.0

ABCDEFGHIJK
LMNOPQRS
TUVWXYZ
ABCDEFGHIJKL
MNOPQRSTU
VWXYZ
1234567890
!@#$%^&*()

Requiem Simplex 2.1

ABCDEFGHIJK
LMNOPQRST
UVWXYZ
ABCDEFGHIJKL
MNOPQRSTU
VWXYZ
1234567890
!@#$%^&*()

Requiem Simplex 2.1

ABCDEFGHIJK
LMNOPQRST
UVWXYZ
ABCDEFGHIJKL
MNOPQRSTU
VWXYZ
1234567890
!@#$%^&*()

Sabotage P.138

Sabotage

ABCDEFGHIJKLMNOPQ
RSTUVWXYZ
abcdefghijklmnopqrst
uvwxyz
1234567890
!@#$%^&*()

Sci-Fi Classic P.140

Sci-Fi Classic

ABCDEFGHI
JKLMNOPQ
RSTUVW
XYZ
abcdefghi
jklmnopqr
stuvwxy
1234567
890

Sabotage P.138

Sabotage

ABCDEFGHIJKLMNOPQ
RSTUVWXYZ
abcdefghijklmnopqrst
uvwxyz
1234567890
!@#$%^&*()

Sci-Fi Classic P.140

Sci-Fi Classic

ABCDEFGHI
JKLMNOPQ
RSTUVW
XYZ
abcdefghi
jklmnopqr
stuvwxy
1234567
890

Talking Drum

ABCDEFGHIJK
LMNOPQRSTU
VWXYZ
abcdefghijklmn
opqrstuvwxyz
1234567890
!@#%+*()

Talking Drum Caps ITC

ABCDEFGHIJK
LMNOPQRST
UVWXYZ
ABCDEFGHIJ
KLMNOPQRS
+UVWXYZ
1234567890
!@#%PG*()

Talking Drum

ABCDEFGHIJK
LMNOPQRSTU
VWXYZ
abcdefghijklmn
opqrstuvwxyz
1234567890
!@#%+*()

Talking Drum Caps ITC

ABCDEFGHIJK
LMNOPQRST
UVWXYZ
ABCDEFGHIJ
KLMNOPQRS
+UVWXYZ
1234567890
!@#%PG*()

Technique P.144

Technique Light

ABCDEFGHIJKLMNOPQRSTUV
WXYZ
abcdefghijklmnopqrstuvwxyz
1234567890 at no $%^&*()

Technique Regular

ABCDEFGHIJKLMNOPQRSTUV
WXYZ
abcdefghijklmnopqrstuvwxyz
1234567890 at no $%^&*()

Thin Man P.146

Thin Man Regular

ABCDEFGHIJKL
MNOPQRSTUV
WXYZ
ABCDEFGHIJKL
MNOPQRSTUV
WXYZ
1234567890
!@#$%^&*()

Technique P.144

Technique Light

ABCDEFGHIJKLMNOPQRSTUV
WXYZ
abcdefghijklmnopqrstuvwxyz
1234567890 at no $%^&*()

Technique Regular

ABCDEFGHIJKLMNOPQRSTUV
WXYZ
abcdefghijklmnopqrstuvwxyz
1234567890 at no $%^&*()

Thin Man P.146

Thin Man Regular

ABCDEFGHIJKL
MNOPQRSTUV
WXYZ
ABCDEFGHIJKL
MNOPQRSTUV
WXYZ
1234567890
!@#$%^&*()

Thin Man P.146

Thin Man Drunk

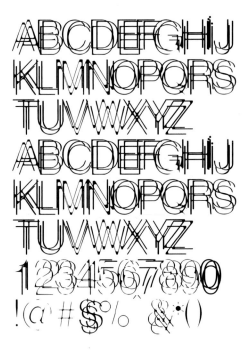

Udo P.148

Udo Leaned

ABCDEFGHIJKLMNOP
QRSTUVWXYZ
abcdefghijklmnop
QRSTUVWXYZ
1234567890
!@#$%^&*()

Thin Man P.146

Thin Man Drunk

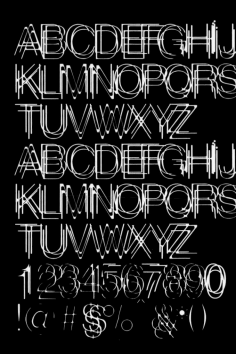

Udo P.148

Udo Leaned

ABCDEFGHIJKLMNOP
QRSTUVWXYZ
abcdefghijklmnop
QRSTUVWXYZ
1234567890
!@#$%^&*()

Udo

ABCDEFGHIJKLMNOP
QRSTUVWXYZ
abcdefghijklmnop
QRSTUVWXYZ
1234567890
!@#$%^&*()

Udo Wide

ABCDEFGHIJKLM
NOPQRSTUVWXYZ
abcdefghijklm
nopqrstuvwxyz
1234567890
!@#$%^&*()

Udo Wide Leaned

ABCDEFGHIJKLM
NOPQRSTUVWXYZ
abcdefghijklm
nopqrstuvwxyz
1234567890
!@#$%^&*()

Udo P.148

Udo

ABCDEFGHIJKLMNOP
QRSTUVWXYZ
abcdefghijklmnop
QRSTUVWXYZ
1234567890
!@#$%^&*()

Udo Wide

ABCDEFGHIJKLM
NOPQRSTUVWXYZ
abcdefghijklm
nopqrstuvwxyz
1234567890
!@#$%^&*()

Udo Wide Leaned

ABCDEFGHIJKLM
NOPQRSTUVWXYZ
abcdefghijklm
nopqrstuvwxyz
1234567890
!@#$%^&*()

Unisphere P.150

Unisphere P.150

Unisphere Light

ABCDEFGHIJ
KLMNOPQRS
TUVWXYZ
abcdefghijklm
nopqrstuv
wxyz
1234567890
!@#$%&*()

Unisphere Light

ABCDEFGHIJ
KLMNOPQRS
TUVWXYZ
abcdefghijklm
nopqrstuv
wxyz
1234567890
!@#$%&*()

Unisphere Light Italic

ABCDEFGHIJ
KLMNOPQRS
TUVWXYZ
abcdefghijklm
nopqrstuv
wxyz
1234567890
!@#$%&()*

Unisphere Light Italic

ABCDEFGHIJ
KLMNOPQRS
TUVWXYZ
abcdefghijklm
nopqrstuv
wxyz
1234567890
!@#$%&()*

Unisphere P.150

Unisphere Regular

ABCDEFGHIJ
KLMNOPQRS
TUVWXYZ
abcdefghijkl
mnopqrstuv
wxyz
1234567890
!@#$%&*()

Unisphere Italic

ABCDEFGHIJ
KLMNOPQRS
TUVWXYZ
abcdefghijklm
nopqrstuvw
xyz
1234567890
!@#$%&*()

Unisphere P.150

Unisphere Regular

ABCDEFGHIJ
KLMNOPQRS
TUVWXYZ
abcdefghijkl
mnopqrstuv
wxyz
1234567890
!@#$%&*()

Unisphere Italic

ABCDEFGHIJ
KLMNOPQRS
TUVWXYZ
abcdefghijklm
nopqrstuvw
xyz
1234567890
!@#$%&*()

Unisphere Bold

ABCDEFGHI
JKLMNOPQ
RSTUVWXYZ
abcdefghijkl
mnopqrstuv
wxyz
1234567890
!@#$%&*()

Unisphere Bold Italic

ABCDEFGHI
JKLMNOPQ
RSTUVWXYZ
abcdefghijkl
mnopqrstuv
wxyz
1234567890
!@#$%&()*

Unisphere P.150

Unisphere Bold

ABCDEFGHI
JKLMNOPQ
RSTUVWXYZ
abcdefghijkl
mnopqrstuv
wxyz
1234567890
!@#$%&*()

Unisphere Bold Italic

ABCDEFGHI
JKLMNOPQ
RSTUVWXYZ
abcdefghijkl
mnopqrstuv
wxyz
1234567890
!@#$%&()*

Whiplash

Whiplash Regular

ABCDEFGHIJKLMN
OPQRSTUVWXYZ
abcdefghijklmnopqr
stuvwxyz
1234567890
!@#$%^&*()

Whiplash Regular Mono

ABCDEFGHIJKLM
NOPQRSTUVWXYZ
a b c d e f g h i j k l m
n o p q r s t u v w x y z
1234567890
! @#$%^&* ()

Whiplash Lineola

ABCDEFGHIJKLM
NOPQRSTUVWXYZ
a b c d e f g h i j k l m
n o p q r s t u v w x y z
1234567890
! @#$%^&* ()

Whiplash P.152

Whiplash Regular

ABCDEFGHIJKLMN
OPQRSTUVWXYZ
abcdefghijklmnopqr
stuvwxyz
1234567890
!@#$%^&*()

Whiplash Regular Mono

ABCDEFGHIJKLM
NOPQRSTUVWXYZ
a b c d e f g h i j k l m
n o p q r s t u v w x y z
1234567890
! @#$%^&* ()

Whiplash Lineola

ABCDEFGHIJKLM
NOPQRSTUVWXYZ
a b c d e f g h i j k l m
n o p q r s t u v w x y z
1234567890
! @#$%^&* (

Wicked P.154

Wicked

ABCDEFGHIJ
KLMNOPQRS
TUVWXYZ
abcdefghijklmn
opqrstuvwxyz
1234567890
!@#$%&*()

Linotype Zapfino P.156

Zapfino Nr. 1

ABCDEFGHIJK
LMNOPQRSTU
VWXYZ
abcdefghijklmnopqrstuv
wxyz
1234567890
!@#$%(&*()

Wicked P.154

Wicked

ABCDEFGHIJ
KLMNOPQRS
TUVWXYZ
abcdefghijklmn
opqrstuvwxyz
1234567890
!@#$%&*()

Linotype Zapfino P.156

Zapfino Nr. 1

ABCDEFGHIJK
LMNOPQRSTU
VWXYZ
abcdefghijklmnopqrstuv
wxyz
1234567890
!@#$%(&*()

Zapfino Nr. 2

ABCDEFGHI
JKLMNOPQ
RSTUVWXYZ
abcdefghijklmnopqrstuvwxyz
1234567890
!@#$%&*()

Zapfino Nr. 3

ABCDEFGHIJ
KLMNOPQR
STUVWXYZ
abcdefghijklmnopqrstuvwxyz
1234567890
!@#$%&*()

Zapfino Nr. 4

ABCDEFGHIJ
KLMNOPQRS
TUVWXYZ
abcdefghijklmnopqrstuvwxyz
1234567890
δ@t—δ&so d

Linotype Zapfino P.156

Zapfino Nr. 2

ABCDEFGHI
JKLMNOPQ
RSTUVWXYZ
abcdefghijklmnopqrstuvwxyz
1234567890
!@#$%&*()

Zapfino Nr. 3

ABCDEFGHIJ
KLMNOPQR
STUVWXYZ
abcdefghijklmnopqrstuvwxyz
1234567890
!@#$%&*()

Zapfino Nr. 4

ABCDEFGHIJ
KLMNOPQRS
TUVWXYZ
abcdefghijklmnopqrstuvwxyz
1234567890
δ@t—δ&so d

Fonts By Alphabet

Fonts By Alphabet

Fonts By Style

Fonts By Style

Fonts By Foundry

Fonts By Foundry

Index

+ISM
+ISM
London, UK
Tokyo, Japan

Contact: Matius Gerardo Grieck and Tsuyoshi Nakazako
Email: a90037tm@plusism.com
Website: http://www.plusism.com

Linotype Library
Linotype Library GmbH
Du-Pont-Strasse 1
D-61352 Bad Homburg Germany

Phone: +49-(0)6172 484 424, -425, -426, -427
Fax: +49-(0)6172 484 429
Email: info@fonts.de
Website: http://www.linotypelibrary.com

LunchBox Studios
LunchBox Studios
PO Box 2442
Venice CA 90294 USA

Contact: Adam Roe
Phone: 310-306-1164
Email: info@lunchboxstudios.com
Website: http://www.lunchboxstudios.com

Nekton Design
Nekton Design
23502 171st Avenue S.E.
Monroe, WA 98272 USA

Contact: Don Barnett
Fax: 425-402-9747
Email: don@donbarnett.com
Website: http://www.donbarnett.com

Phil's Fonts
Phil's Fonts, Inc.
14605 Sturtevant Road
Silver Spring, MD 20905 USA

Contact: Ralph Smith, Owner
Phone: 800-424-2977 or 301-879-0601
Fax: 301-879-0606
Email: sales@philsfonts.com
Website: http://www.philsfonts.com

Psy/Ops ®
Psy/Ops Type Foundry
923 Folsom Street, Tank 5
San Francisco CA 94107 USA

Contact: Rodrigo Cavazos
Phone: 415-896-5788
Fax: 415-896-2290
Email: info@psyops.com
Website: http://www.psyops.com

Shift
Shift
P.O. Box 4
Burlingame CA 94011-0004 USA

Contact: Joshua Distler
Phone: 650-737-1004
Fax: 650-343-3498
Email: sales@shiftype.com
Website: http://www.shiftype.com

Swifty/Typomatic
Typomatic / Swifty Typografix

Contact: Ian Swift (Swifty)
Phone: + 44 020-8991-6865
Fax: + 44 020-8991-6872
Email: swifty@swifty.co.uk and swiftytypo@easynet.co.uk
Website: http://www.swifty.co.uk

[T-26] Type Foundry
[T-26]
1110 N. Milwaukee Avenue
Chicago, IL 60622

Contact: Sun Segura
Phone: 773-862-1201
Fax: 773-862-1214
Email: info@t26.com
Website: http://www.t26.com

2Rebels
2Rebels
6300 Parc / #429
Montreal, Quebec
Canada H2V4H8

Contact: Denis Dulude
Phone: 514-278-9550
Fax: 515-278-7253
Email: info@2rebels.com
Website: http://www.2rebels.com

Index

FOUNDRIES & TYPE DESIGNERS
FEATURE YOUR LATEST RELEASES IN THE NEXT EDITION WEB TYPE 2
CONTACT US VIA EMAIL
DIMENSION@3DIMILLUS.COM

new digital graphic books
from dimensional illustrators, inc.

ExtremeGraphics
Edited by: Kathleen Ziegler and Nick Greco

Digital creatives reach far beyond the limits of cyberspace in this premiere publication of *ExtremeGraphics*, a benchmark collection of electronic imagery. Experience the infinite capabilities of the computer as more than 300 full-color images break graphic rules and shatter your concept of reality. More than 30 digital visionaries featured in *ExtremeGraphics* exemplify the limitless possibilities of the new-media generation. Each provocative image transforms reality and illusion into a shifting, quixotic vision never before imagined. Journey beyond the limits of the known visual universe. *ExtremeGraphics* will propel you through the creative cosmos of cyberspace, exceed the limits of your expectations and push them to the extreme. *Cover Image: Michael Morgenstern*

The Designers Guide To Web Type: Your Connection To The Best Fonts Online
Edited by: Kathleen Ziegler and Nick Greco

This premiere guide book offers an alphabetical cross section to 70 digital typefonts from the subliminal to the sublime, contemporary to experimental, organic to ornamental, hand-drawn to neoclassic. The type foundries include: Bitstream, Cool Fonts, DsgnHaus, Emigre, Face2Face, fontBoy, Font Shop International, Fountain, GarageFonts, International Typeface Corporation, +ISM, Linotype Library, Lunch Box Studios, Nekton Design, Phil's Fonts, Psy/Ops, Shift, Swifty/Typomatic, T26 and 2Rebels. *Web Type* is divided alphabetically by font name and includes descriptive text, font families and two inspiring typographic illustrations that feature each font in a design application. In addition, website addresses are provided for easy access with more than 200 font families. *Web Type* features typographers from Australia, Austria, Canada, China, England, France, Germany, Italy, The Netherlands, Serbia, Sweden, Thailand and the United States. This one-stop sourcebook showcases the hottest typefonts from the coolest designers online. *Images: 2Rebels and Matius Gerardo Grieck [+ISM]*

Qty. -	Title -	Discount Price -	Int'l Shipping Add $5.00 -	PA Residents Add 7% Tax -	Total
	ExtremeGraphics	$22.95			
	Web Type	$29.95 NEW!			

SHIPPING ADDRESS: (PLEASE PRINT CLEARLY)

Name_____

Firm_____

Address_____

City_____ State_____ Zip_____ (Country)_____

_____Check (drawn on a U.S. bank only) _____Visa/MasterCard _____MoneyOrder

Credit Card#_____

Signature_____Exp.Date_____

Phone_____

Send Payment to:

Dimensional Illustrators, Inc.
362 2nd Street Pike - #112
Southampton, PA 18966 USA
215-953-1415 Phone
215-953-1697 Fax (*24 hours*)
dimension@3dimillus.com Email
3dimillus.com Online Orders
U.S. Orders Shipped in 2 weeks.
Overseas orders shipped in 4-6 weeks.